The Campus History Series

THE COLLEGE OF WILLIAM AND MARY

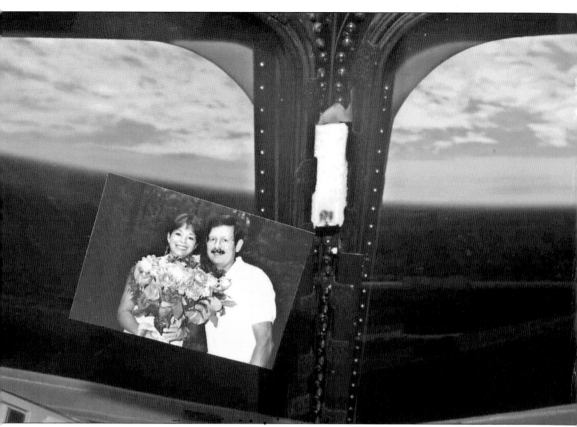

College of William and Mary gymnastics coach Cliff Gauthier and his wife, Linda, received an e-mail from the space shuttle *Columbia* dated January 30, 2003. Their picture is attached to a window looking out at Earth. Astronaut David Brown, class of 1978, tells his former coach, "You are among a small group of people who I believe changed me enough along the way to make this possible." The words were not much different from those of William and Mary student Thomas Jefferson, 1760–1762, who wrote of his beloved instructor William Small, "It was my great good fortune, and what probably fixed the destinies of my life that Dr. William Small of Scotland was then professor of Mathematics." Jefferson probably would have easily understood both the picture and words emailed from space 240 years later. "If I'd been born in space I know I would desire to visit the beautiful Earth more than I've ever yearned to visit to space. It is a wonderful planet," said Brown in another message on January 31. The *Columbia* disintegrated upon reentry the following day. All aboard were lost. (Courtesy Cliff Gauthier.)

ON THE COVER: In the first years of the 20th century, the College of William and Mary is portrayed in a proud photograph of the college library. The portraits hanging from its balconies in the Wren Building are of those who have driven the history of the College since its 17th-century beginnings. The students engrossed in their newspapers would go on to enter the mix of William and Mary alumni that has included presidents, senators, educators, businessmen, and renowned artists. College bell-ringer Henry Billups, far left, would continue his service to the College, culminating in a celebratory ride down Duke of Gloucester Street in a 1952 Plymouth convertible. In the background image, members of the class of 1985, many of them activists in students' rights and affirmative action, stride through Wren Courtyard and into the future. (College of William and Mary.)

The Campus History Series

THE COLLEGE OF WILLIAM AND MARY

CHRIS DICKON

Chris Dickon

ARCADIA
PUBLISHING

Published by Arcadia Publishing
Charleston, South Carolina

Printed in the United States of America

Library of Congress Catalog Card Number: 2006932627

For all general information contact Arcadia Publishing at:
Telephone 843-853-2070
Fax 843-853-0044
E-mail sales@arcadiapublishing.com
For customer service and orders:
Toll-Free 1-888-313-2665

Visit us on the Internet at www.arcadiapublishing.com

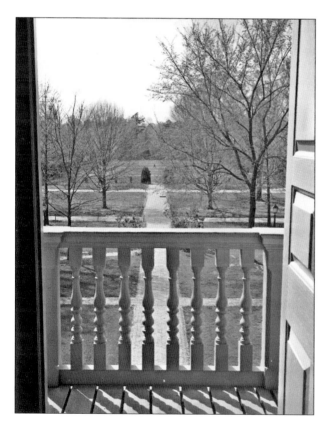

The balcony of the Wren Building provides a timeless view over three centuries of a "certain place" that helped to found a nation, educate its youth, and explore the world. (College of William and Mary.)

CONTENTS

ACKNOWLEDGMENTS

When I moved to Norfolk, Virginia, in 1978, I didn't have a whit of knowledge about the absolute, foundational history of southeast Virginia as the nation's birthplace beyond what I could dimly remember from prior book learning. But I quickly came around as I took on the job of a public radio and television producer in an area that stretched from Williamsburg south to the North Carolina line. Everywhere I turned, I could touch the beginnings of American history, and in producing radio and television programs about it I came to a fuller understanding of how complex and remarkable those first years had been. That history is most exemplified to the larger world by Colonial Williamsburg, the wonderfully restored original town out of whose streets and buildings came many of the ideas that we live by today as Americans. But always, almost quietly, sitting in the background of Colonial Williamsburg was the campus of the College of William and Mary. It was the go-to source for the research and the resource materials of our history, and it was the place to go when you wanted to place the public's business—its deliberations of politics and public affairs—on a scale that would give them extra meaning and effect.

In 1996, I was privileged to be able to join with the College in the production of a political debate between U.S. senator John Warner and his challenger for that office, Mark Warner, who would later become governor of Virginia. The debate was grant-supported by the Corporation for Public Broadcasting and broadcast statewide. My partner in the production from the college side was Associate Vice President for Public Affairs William T. Walker. It was some years later that Bill and I got back together, and he agreed to assist me in the development of this book. Telling the story of a college, particularly this college, is not as easy as it might appear, and it would not have been possible without Bill's patient attention from the outset. This is to acknowledge first the role and importance of the College of William and Mary in our American history and second Bill Walker's assistance, along with that of many others at the College, in helping to get the story told.

FOREWORD

At William and Mary—perhaps more than at any other American university—the competing attractions of past, present, and future are readily apparent. It may be the richness of the College's history contrasted with the bright promise of achievements yet to come; the statue of Lord Botetourt surrounded by animated, enthusiastic freshmen; or the elegant 17th-century Wren Building, just yards away from one of the world's most advanced laboratories.

Whatever form the phenomenon takes, it's this temporal blend that makes the College so intriguing. It's that, and it's much more. At William and Mary, past, present, and future are inextricably bound by an enduring continuity of values—one that has nurtured students, Virginia, and the nation for more than 300 years.

Founded by royal charter in 1693, the College of King William III and Queen Mary II has long been dedicated to the proposition that life-changing educational experiences are principally the product of extended conversations between professors and students. Such intellectual partnerships not only enable an exchange of information and ideas, but they also promote a deeper consideration of ideals and values.

William and Mary professors have always taught more with their lives than with their lectures, using a gentle pedagogy fostering remarkable student development. When the young Thomas Jefferson enrolled at William and Mary in 1760, it was his "great good fortune" to meet master teacher William Small, a Scottish professor of natural philosophy, who introduced him to the Enlightenment principles that formed the intellectual basis of the American Revolution. According to Jefferson, the intellectual friendship "fixed the destinies of my life."

Although William and Mary has educated two other U.S. presidents (James Monroe and John Tyler), alumni need not achieve high political office to testify to the influence of professors in their lives. Indeed almost every alumnus talks about the influence of a favorite professor, the support of a coach, or the inspiration of a faculty mentor. To make these personal exchanges possible, the College has maintained a human scale, including an 11:1 student-to-faculty ratio that is exceptionally low for a public university.

In addition to building a strong intellectual base, extended conversations between students and professors often inspire an uncommon devotion to the common good. In 2006, for instance, the student body donated more than 325,000 hours to service projects in Williamsburg, across the country, and throughout the world. Our young women and men have built homes for Mexico's poor, taught computer literacy in Palestine, fought

7

the AIDS pandemic in Africa, and undertaken hundreds of other projects that benefit disadvantaged people across the globe. All told, more than 70 percent of our student body of 7,500 volunteer during their campus careers, and many go on to lives of service following graduation.

In so doing, the graduates emulate the College itself, which partners with Virginia's school districts to improve education, monitor environmental conditions in the Chesapeake Bay, work with the Commonwealth's distressed cities, and stimulate economic development through research. Over the past decade, annual research expenditures at the university have more than doubled and in 2006 stood at $43 million. In keeping with the institution's devotion to students, faculty members often incorporate undergraduates as well as graduate students into their research projects, a strategy that provides additional opportunities for mentoring and builds the confidence of young people to undertake independent projects.

William and Mary's commitment to the professional and personal development of each student yields spectacular results. In the past few years, the College has graduated five Rhodes scholars and many Fulbright, Goldwater, and Truman scholars. Moreover, our students gain access to medical, law, and graduate schools well in excess of the national averages. Whatever field they choose, graduates leave campus with the strong intellectual skills and sensitive hearts necessary to heal a nation and change the world.

Devotion to students, academic excellence, independent inquiry, the public good— these are the values that unify our college and bind our graduates in a strong community of achievement and responsibility. They are also the reasons that William and Mary is widely recognized as the best small public university in the nation. While we are proud of the appellation, it's one we wear lightly—with the full knowledge that true success can ultimately be measured only by the lives of our graduates.

It's difficult to compress 300 years of history into the 200 pictures chosen by Chris Dickon. It's my hope, however, that the rich mosaic formed by these images will tell a story of a university that has transformed education into a life-changing experience, while contributing profoundly to the development of America and its place in the world.

<div align="right">

—Gene R. Nichol
President
The College of William and Mary

</div>

One

A Certain Place

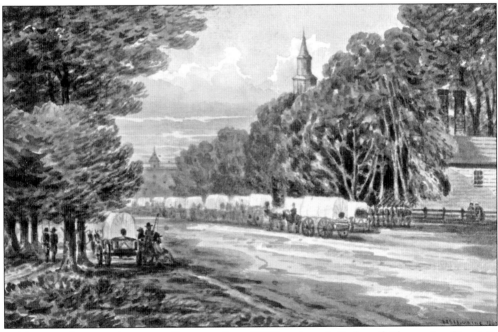

Soldiers and covered wagons line up along Williamsburg's Duke of Gloucester Street in 1862, with the steeple of Bruton Parish Church and the cupola of the College Building visible in the background. By this time, the history of city, college, and church had been intertwined for over a century and a half. Williamsburg had been settled in 1632 as Middle Plantation; it became the capital of the Virginia colony in 1699, and then the first American city as designated by royal charter in 1722. Though it had and would retain a sense of place that was both American and British, it was a site of origin of the American Revolution and a philosophical capital of the movement to declare American independence from Great Britain. Through all of those years, events in Williamsburg had been intellectually driven in concert with the planning and development of the College of William and Mary. (Library of Congress.)

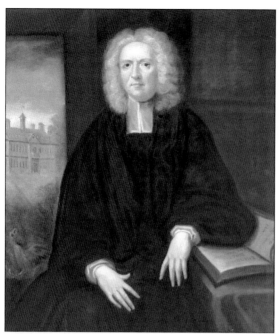

The Reverend James Blair held the prominent position of commissary of the Church of England in Virginia. He was part of a coalition that included the royal governor of the colony, Francis Nicholson, and a group of influential members of the colonial legislature formed to promote both the college and a new capital city away from Jamestown. In 1691, the General Assembly sent Blair to England to obtain a royal charter and financial support for the new enterprise. (College of William and Mary, Muscarelle Museum.)

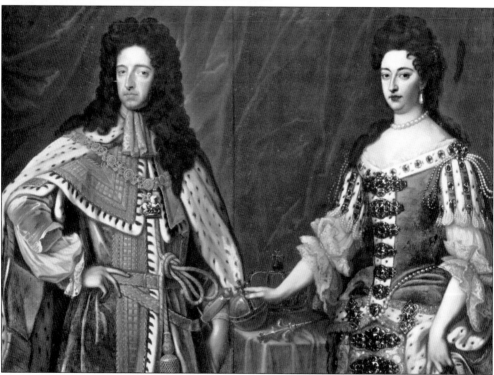

On February 8, 1693, King William III and Queen Mary II granted a charter for the college that would bear their names. King William responded to Blair's request by saying, "I am glad that the colony is upon so good a design & I will promote it to the best of my power." Blair returned to Virginia with construction funds, an endowment that included two 10,000-acre land grants, and revenue for operation. (Colonial Williamsburg Foundation.)

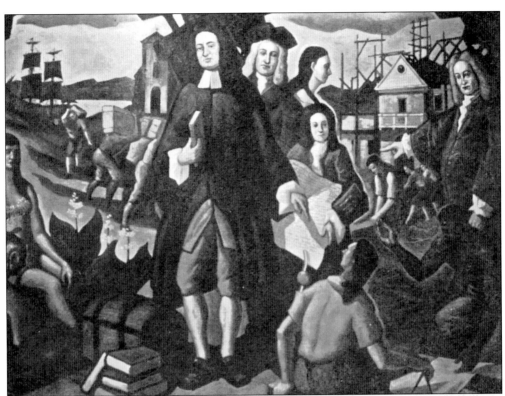

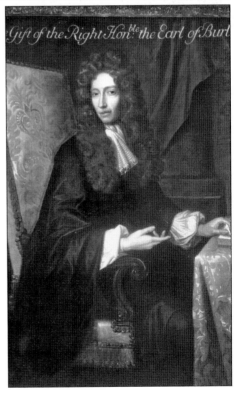

Gift of the Right Honble the Earl of Burl

James Blair, seen in this 20th-century painting with the College Building under construction in the background, served as the college president from 1693 until his death in 1743. In 1784, Benjamin Franklin would write that some of Blair's early fund-raising efforts were premised on the need for a college in the colony to "educate and qualify young men to be ministers of the gospel. The people of Virginia," he said, "had souls to be saved." The lord of the British treasury, Sir Edward Seymour, is reported to have replied, "Souls! Damn your Souls. Make tobacco." (College of William and Mary.)

In 1660, Sir Robert Boyle (right), along with architect Sir Christopher Wren, founded the Royal Society of London for the Promotion of Natural Knowledge. Regarded in retrospect as the first modern chemist, he applied his Protestant faith to charitable acts and the study of nature. Upon his death in 1691, executors of his estate purchased Brafferton Manor in Yorkshire, dedicating a portion of its revenues to the support of the new college in Virginia. (College of William and Mary, Muscarelle Museum.)

11

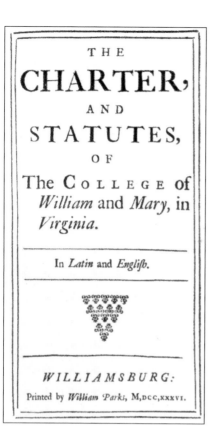

THE

CHARTER,

AND

STATUTES,

OF

The COLLEGE of
William and *Mary*, in
Virginia.

In *Latin* and *English*.

WILLIAMSBURG:

Printed by *William Parks*, M,DCC,XXXVI.

The charter of February 8, 1693, first printed in Virginia in 1736, directed that the "youth may be piously educated in good letters and Manners, and that the Christian Faith may be propagated among the Western Indians." It was, said the charter, to be "a certain place of universal Study, a perpetual College of Divinity, Philosophy, Languages, and other good Arts and Sciences." Until the American Revolution of 1776, most chancellors of the College would be the Bishop of London or the Archbishop of Canterbury. (College of William and Mary.)

On December 20, 1693, a tract of 330 acres was purchased for £170, and the college site was marked by boundary stones. Two of the stones survive into the 21st century, maintained in the college archives. (College of William and Mary.)

Construction of the first half of the College Building was virtually completed in 1700, and it became the site of the first legislative meeting of the Virginia General Assembly in Williamsburg on December 5 of that year. In the first of the many fires that would dot the history of the College, the building was burned to its walls in October 1705. The old walls would be reused in its reconstruction between 1710 and 1716. (College of William and Mary.)

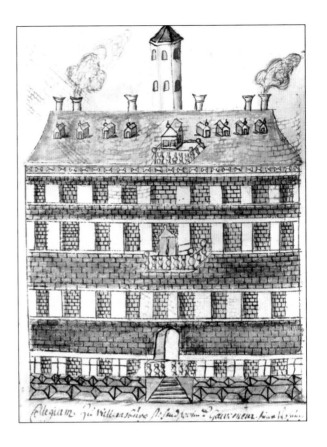

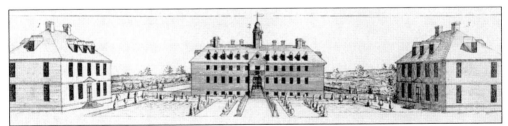

The College Yard, c. 1733–1744, included the three buildings that would carry the history of the College into the 21st century. In 1723, the Brafferton building, left, was constructed with funds from the estate of Robert Boyle to house what would be called the Indian School, intended to educate the native population. In 1732, a chapel was added as the south wing of the College Building, center, soon to be followed by completion of the President's House, right. (Colonial Williamsburg Foundation.)

Bursar's books of the 1760s and 1770s record tuition and fees for two students of note. Thomas Jefferson, of a planter family in Albemarle County, entered the College at age 17 and paid just more than £28 for tuition and board over two years. He drafted the Declaration of Independence at age 33 and became the nation's third president in 1801. James Monroe had come from parents who were tobacco farmers in Westmoreland County, paid £13 for board and tuition in 1776, and went on to be elected the nation's fifth president in 1816. (College of William and Mary.)

Cited by Thomas Jefferson as the professor who set the course of his life, Scottish-born William Small returned to Great Britain in 1764. He would not return to the College until 2005, and only then in the form of this portrait. "Even though the piece had not been cleaned or conserved," said the *William and Mary News*, " it was remarkable. The face glowed with the intellectual curiosity and enthusiasm of a great teacher, the eyes were piercing." (College of William and Mary.)

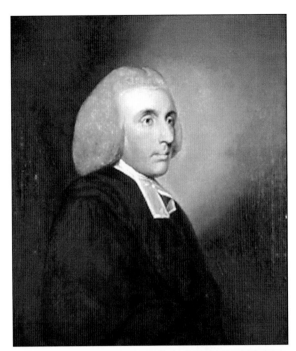

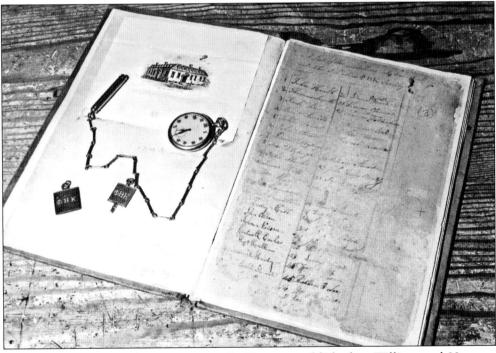

The fraternal society Phi Beta Kappa (PBK) was established at William and Mary on December 5, 1776. The William and Mary chapter was discontinued for long periods in the 18th and 19th centuries, but in 1779 it issued charters for Harvard and Yale, and was reestablished at William and Mary in 1893. The original minutes of PBK are shown, with a PBK key, watch, pencil, and chain owned by an early-20th-century member. (College of William and Mary.)

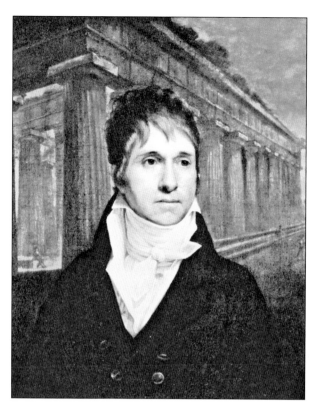

William Short served as PBK president at William and Mary from 1778 to 1781. Short would become a protégé and personal secretary to Thomas Jefferson, which would lead to his appointment by Pres. George Washington as the nation's first career diplomat. (College of William and Mary.)

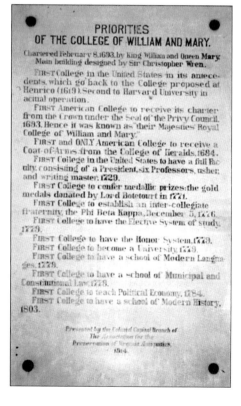

PRIORITIES
OF THE COLLEGE OF WILLIAM AND MARY.

Chartered February 8,1693, by King William and Queen Mary. Main building designed by Sir Christopher Wren.

First College in the United States in its antecedents, which go back to the College proposed at Henrico (1619). Second to Harvard University in actual operation.

First American College to receive its charter from the Crown under the Seal of the Privy Council 1693. Hence it was known as "their Majesties' Royal College of William and Mary."

First and ONLY American College to receive a Coat-of-Arms from the College of Heralds,1694.

First College in the United States to have a full Faculty consisting of a President, six Professors, usher, and writing master, 1729.

First College to confer medallic prizes: the gold medals donated by Lord Botetourt in 1771.

First College to establish an inter-collegiate fraternity, the Phi Beta Kappa, December 5, 1776.

First College to have the Elective System of study, 1779.

First College to have the Honor System, 1779.

First College to become a University, 1779.

First College to have a school of Modern Languages, 1779.

First College to have a school of Municipal and Constitutional Law, 1779.

First College to teach Political Economy, 1784.

First College to have a school of Modern History, 1803.

Presented by the Colonial Capital Branch of The Association for the Preservation of Virginia Antiquities, 1914.

The beginning of PBK was just one of a number of American firsts for the College, as noted in a plaque dated 1914. Among others are the first with a full faculty in 1729, first to develop an honor system, become a university, and develop a course of Modern Languages in 1779. These firsts have been noted as the basis of the "Priorities of the College of William and Mary." (College of William and Mary.)

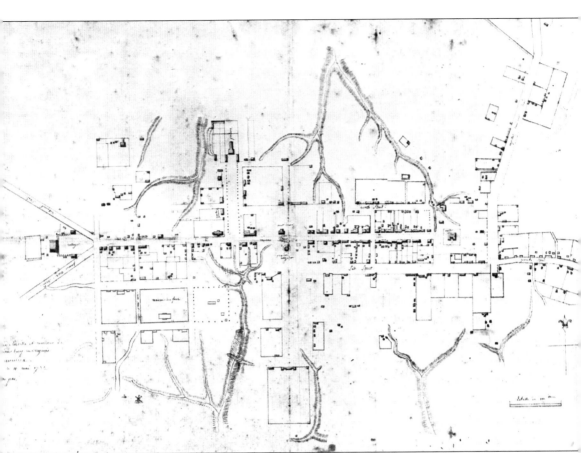

College classes were suspended in the Revolutionary War from January 1781 until the fall of 1782. The "Frenchman's Map" of Williamsburg is dated May 11, 1782, and is believed to have been drawn by a member of General Rochambeau's forces. It includes the college campus in the "V" formed by Jamestown and Richmond Roads, left. The President's House had been gutted by fire while used as a hospital for French soldiers, and was reconstructed by 1786 with financial assistance from the French government. In 1780, the capital of Virginia was moved from Williamsburg to Richmond, and the town and College fell into difficult times. In 1792, geographer Reverend Jedidiah Morse wrote, "Everything in Williamsburg appears dull, forsaken and melancholy . . . The unprosperous state of the college, but principally the removal of the seat of government, have contributed much to the decline of this city." (Earl Gregg Swem Library, College of William and Mary.)

By 1787, a large number of William and Mary students had played significant roles in the founding of the new nation, some very well known and others since forgotten, left. Peyton Randolph was president of the First Continental Congress that guided the beginnings of Revolution. George Wythe was signer of the Declaration of Independence, the first American professor of law, and a mentor to Thomas Jefferson, James Monroe, and eventual Supreme Court justice John Marshall. Edmund Randolph was born in Williamsburg in 1753 and became a key theorist on congressional representation in the Constitutional Convention of 1787. An engraving of the college room of John Randolph (below), who would go on to become both a representative and senator from Virginia, shows barren and worn quarters available to students in 1792 during the difficult years following the Revolutionary War. (College of William and Mary.)

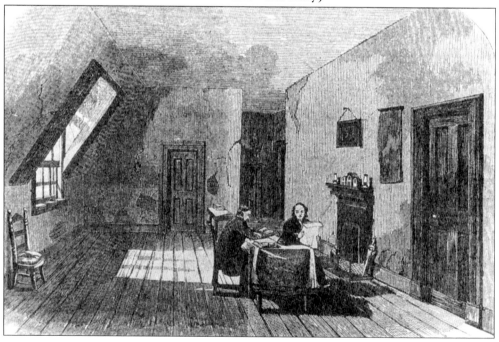

From its founding, the College gained some of its revenues as a licensor and commissioner of surveyors for Virginia. One of those commissioned was George Washington, surveyor of Culpeper County in 1749 at age 17. Upon his death in 1799, former president Washington was chancellor of the College—his first and last public offices having been held under college auspices. Among the licenses granted by the College was that of George Rogers Clark, below, in 1784. As a colonel in the Revolutionary War, Clark had been credited with helping to wrest the Northwest Territory from the British. His younger brother was William Clark, who went on to explore the Northwest Territory with Meriwether Lewis. (College of William and Mary.)

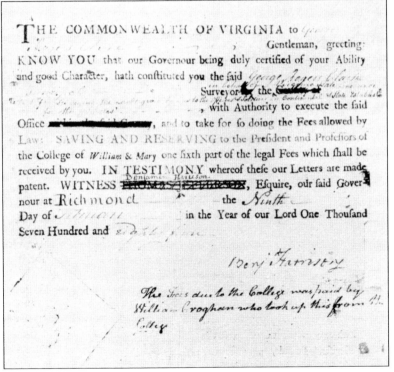

THE COMMONWEALTH OF VIRGINIA to *George*
, Gentleman, greeting:
KNOW YOU that our Governour being duly certified of your Ability and good Character, hath constituted you the said *George Rogers Clark*
Surveyor of the
, with Authority to execute the said Office , and to take for so doing the Fees allowed by Law: SAVING AND RESERVING to the President and Professors of the College of *William* & *Mary* one sixth part of the legal Fees which shall be received by you. IN TESTIMONY whereof these our Letters are made patent. WITNESS ~~THOMAS~~ *Benjamin Harrison*, Esquire, our said Governour at *Richmond* the *Ninth* Day of in the Year of our Lord One Thousand Seven Hundred and

Benj Harrison

The Fees due to the College was paid by William Croghan who took up this from the College

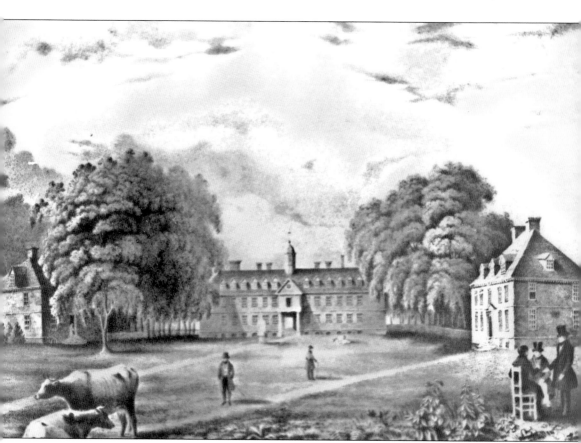

This popular representation of the College campus by artist Thomas Millington, son of faculty member John Millington, a writer of one of the first American textbooks on civil engineering, depicts its three main buildings in 1840. As shown, it was a campus where cows and learned gentlemen could freely mingle, though some lamented this quality. A Spanish teacher, Col. C. de la Pena, described Williamsburg to friends in 1827 as a place of "many half-ruined wooden houses, which afford a tranquil and peaceful asylum to insects of every description. The streets give an idea of the wonderful fertility of this soil, by their being covered with grass, and several cows, pigs, horses, mules and goats are to be seen pasturing undisturbed along them. I thought I was transported to Noah's Ark." Colonel de la Pena is not recorded on the faculty rolls of the following years. (College of William and Mary.)

Two

THE PHOENIX

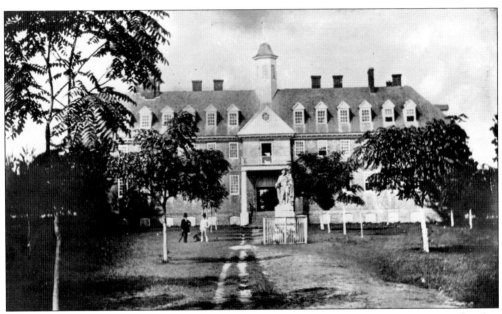

In 1856, the College Building looked much the same as it had since 1716. This daguerreotype, the earliest known photographic image of the building, records its appearance on the eve of the second of the three fires that have ravaged it. The fire of February 8, 1859, gutted the structure and destroyed the contents of the library and a valuable collection of historic scientific instruments. The building would burn a third time in 1862. In 1931, it was named the Sir Christopher Wren Building after the great British architect to whom the design of the original building was attributed by an 18th-century author. That attribution is still debated today, and history holds no definitive answer. The oldest college building in the United States, the Wren is still used for classrooms and is considered the "soul of the college." The statue is of Norborne Berkeley, Baron de Botetourt, a college benefactor and colonial governor of Virginia who is buried beneath the building's chapel. (College of William and Mary.)

The fire of 1859 was followed by immediate reconstruction using the old building's walls, and the college was reopened, above, October 13 of that year under a new chancellor, John Tyler, an 1806 graduate who would become the 10th president of the United States in 1841. With the advent of the Civil War, most of the faculty and students joined the Confederate army, and the building became a barracks and hospital. In 1862, Williamsburg was taken by Union troops. The Brafferton was used as headquarters for the Union garrison, and the Wren was once again set afire, this time by drunken soldiers of the 5th Pennsylvania Cavalry. By 1865, what remained of the building had been turned into a small fort against Confederate forces. Cannons were placed inside, and barricades were set up on surrounding roads. (College of William and Mary.)

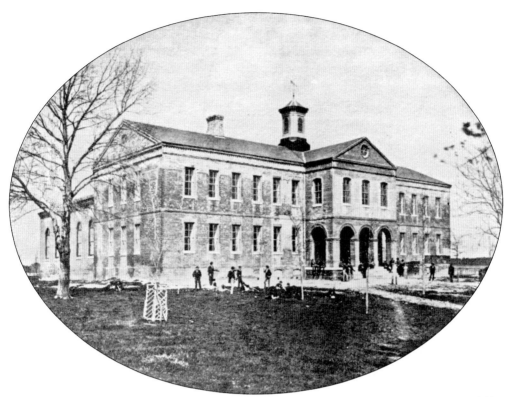

In July 1868, the faculty voted to suspend classes again until the College Building could be rebuilt, and the rest of the campus rejuvenated. Despite the unwillingness of the federal government to pay reparations for the damage, the building was reopened in 1869, and classes resumed on October 13. (College of William and Mary.)

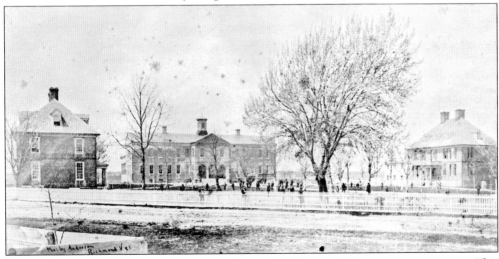

By 1870, the physical structure of the College of William and Mary was again intact. This photograph shows the Brafferton, left; the College Building with its chapel, center; and the President's House, right. The Brafferton was by now the third-oldest college building in America, after the Wren and Harvard's Massachusetts Hall. The College held its first commencement since the Civil War on July 5, 1870. (Colonial Williamsburg Foundation.)

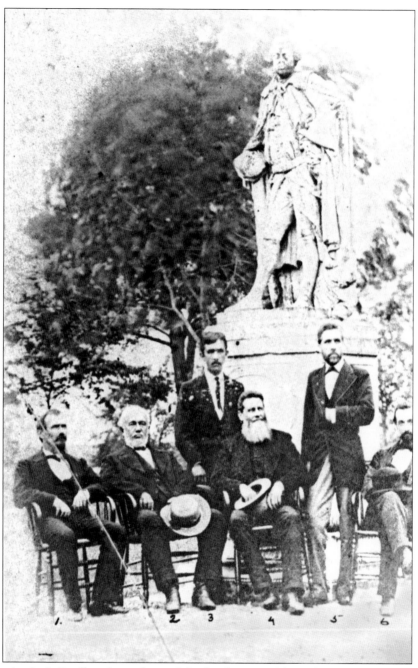

Pres. Benjamin S. Ewell and members of the faculty assemble at the feet of Lord Botetourt, c. 1872. Among them, Lyman B. Wharton (1) was an ordained minister who had served as a chaplain of the Fifty-Ninth Virginia Regiment in the Civil War and became professor of languages at the College. President Ewell (2) was an 1832 graduate of West Point and had been a civil engineer for the Pennsylvania Railroad before coming to the College in 1848. Rev. George Wilmer (4) was professor of belles lettres. He was appreciated for his religiosity, though the quality made him unapproachable to some, and was paid $1,000 annually. (College of William and Mary.)

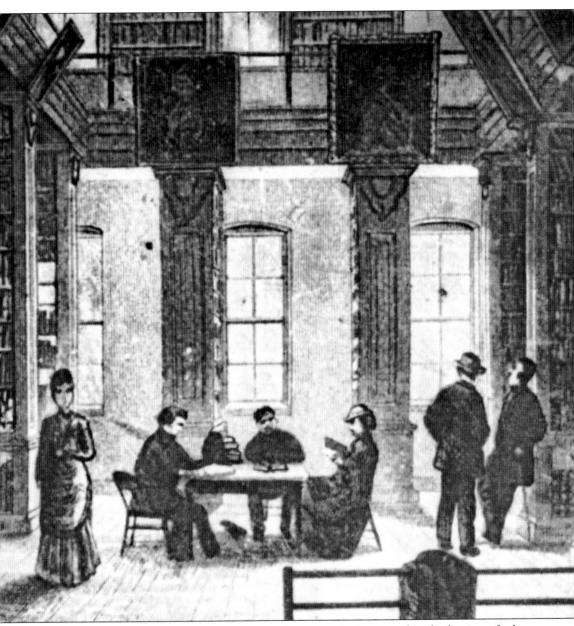

The college library is shown in 1880, the darkness of the image a foreshadowing of what was to come. Money and enrollment were scarce, and hoped-for reparations for Civil War damage had not been received. In 1874, President Ewell embarked on a national campaign emphasizing the unique place of the College in American history. The effort, accompanied by continuing efforts to gain reparations, was not successful, but planning by some that would merge the College with other institutions was resisted. In 1881, the College was forced to close, but the college bell was rung by President Ewell at the beginning of what would have been each subsequent academic year to remind the town that the College was still there. By this time, the mythic notion of the phoenix rising from its own ashes had been well attached to the lore of the Wren Building, and it would prove to apply to the full College as well. (College of William and Mary.)

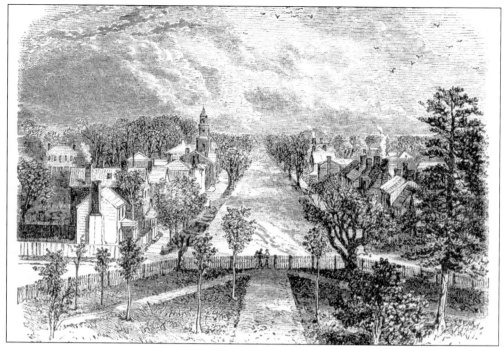

In 1887, the view of Williamsburg from the Wren Building and down Duke of Gloucester Street, above, was of a small town on the verge of being forgotten. The colonial section, mapped below, had fallen into disrepair as the modern town was built around it. But it was a sleepy place. The Chesapeake and Ohio Railroad had reached the town in 1881 as it moved toward a coastal terminus at Newport News. (Sargeant Memorial Room, Kirn Library, Norfolk.)

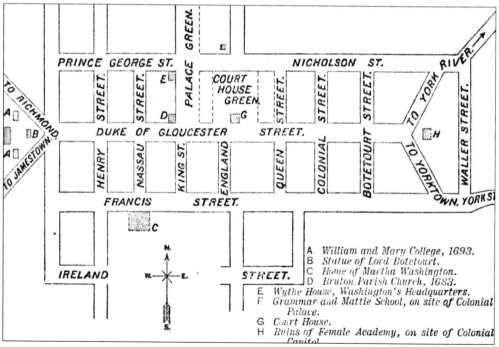

A William and Mary College, 1693.
B Statue of Lord Botetourt.
C Home of Martha Washington.
D Bruton Parish Church, 1683.
E Wythe House, Washington's Headquarters.
F Grammar and Mattie School, on site of Colonial Palace.
G Court House.
H Ruins of Female Academy, on site of Colonial Capitol

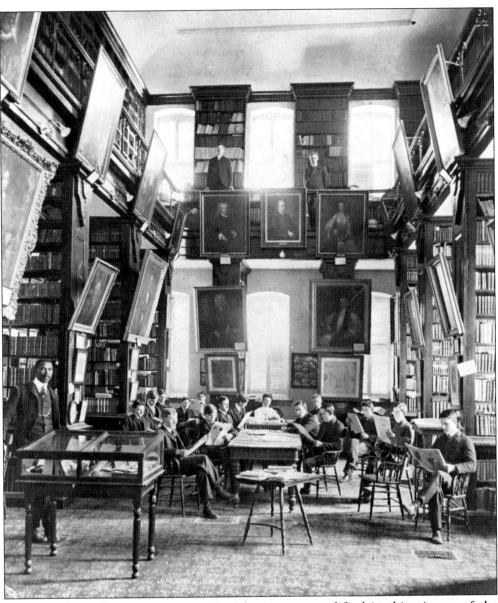

In 1888, the College was reopened with vigor, exemplified in this picture of the Wren Building in later years. The College, said President Ewell in 1887, "hath become as an oak whose leaf fadeth, and as a garden that has no water." In March of the following year, the Virginia General Assembly appropriated $10,000 toward its reopening, with the condition that it include a program of teacher-training in its curriculum. In August, leadership of the College was assumed by Lyon G. Tyler, son of U.S. president John Tyler. The reopening also saw an expansion of curriculum beyond the classical fields of its previous years. "We want the public to know that we are progressive teachers . . . [and] shall pour new blood into the veins of public education," wrote Prof. John Lesslie Hall. (College of William and Mary.)

Eventually the library in the Wren, left, contained 7,000 volumes, "several important portraits and relics of the past," and was open to students three times each week. In-state students of the College paid $100 in tuition, expenses and fees, including $10 for books. The cost was $143 for those from outside Virginia. Reports on each student were made quarterly, and the college catalogue admonished that "Parental authority is a valuable adjunct in sustaining a proper efficiency in studying. The College will not tolerate an idle or vicious student." (College of William and Mary.)

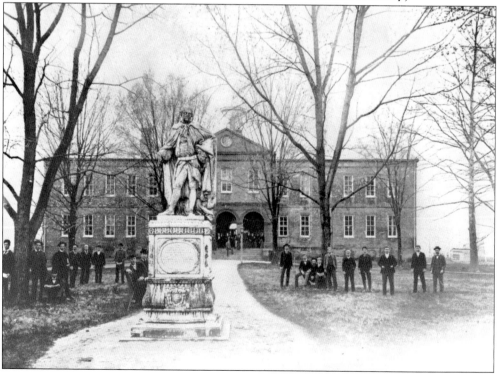

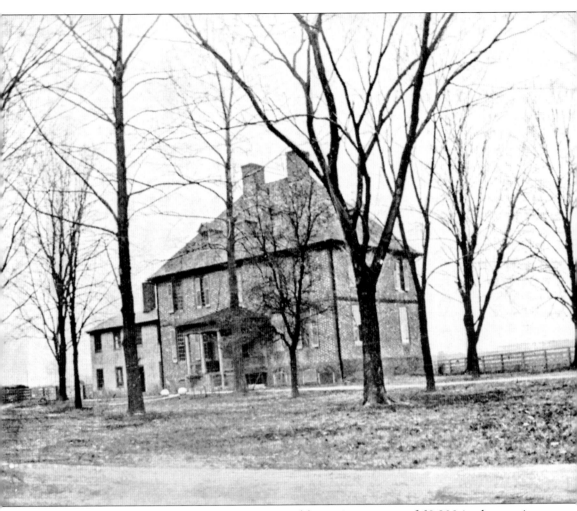

The reopening of the College was accompanied by an investment of $2,900 in the repair of the three main buildings and the college hotel. President Tyler wrote of the newly revived school: "First in the number and importance of Alumni furnished to the history of the Union, it was also first in establishing the courses and systems of instruction which have now become universally recognized." By 1899, College alumni included 4 signers of the Declaration of Independence; 3 presidents; 4 Supreme Court justices, including John Marshall; 29 U.S. senators; and 66 members of the House of Representatives. In 1900, President Tyler succeeded in wresting another $15,000 from the General Assembly as an annual appropriation, and $10,000 for campus improvements. (College of William and Mary.)

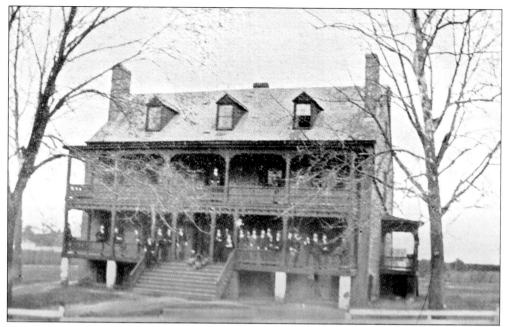

The college hotel on Jamestown Road, above, was repaired and refurnished to continue its role as a residence for the student body, and also housed the college steward and his family. Of the 102 students of 1888, most lived in the hotel or the Brafferton, below, which had long since ceased to function as the Indian School that was intended by the estate of Sir Robert Boyle. Others lived in Williamsburg boardinghouses that had been approved by faculty. Most students were poor, and some were as young as 15 years of age. Financial assistance was available in the form of tuition offsets and scholarships, especially for future teachers. By 1906, the student body numbered 244. (College of William and Mary.)

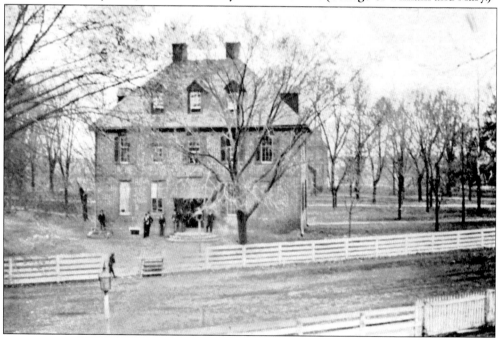

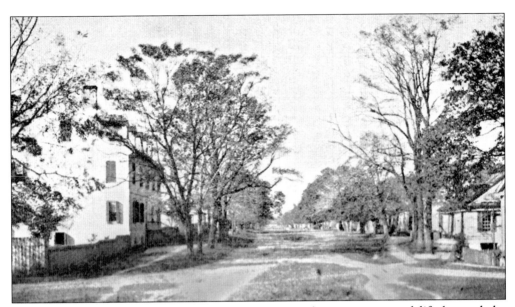

Williamsburg's Duke of Gloucester Street in 1899, above, represented life beyond the college precincts, perhaps made more attractive in reaction to strict rules. All students had to attend morning roll call and chapel services. Ball-playing near college buildings incurred a 25¢ fine, and the use of cards, billiards, or liquor was forbidden. Lights had to be out by midnight. Travel more than six miles from Williamsburg had to be authorized. That did not discourage occasional nights of rowdyism as far away as Yorktown or vandalism on neighboring farms. The first lines of the college song of 1899, below, harkened back to a perhaps simpler time. (College of William and Mary.)

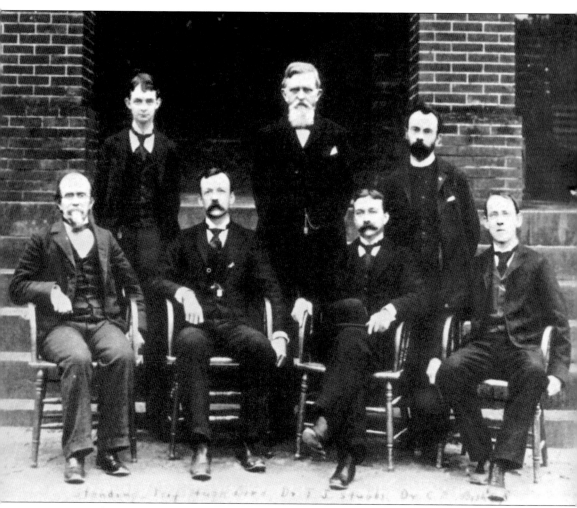

As president and full-time professor of philosophy, economics, government, and psychology, Lyon Tyler became leader of what came to be known as "The Seven Wise Men"—pivotal figures in the College's history. For a salary of just $1,000 annually each, they would succeed in reenergizing the College and preparing it for the 20th century. Seated from left to right are professor of languages Lyman Brown Wharton (see page 24); Pres. Lyon Tyler; Van Franklin Garrett, who had earned a medical degree at Bellevue Hospital Medical College in Manhattan and became William and Mary's sole teacher of science; and John Lesslie Hall, professor of Anglo-Saxon literature. Standing from left to right are Hugh Stockdell Bird, a professor of pedagogy who fulfilled the College's new mission of training male teachers for public schools; Thomas Jefferson Stubbs, professor of mathematics and organizer of the school's first formal baseball team in 1894; and Charles Edward Bishop, who had received his doctorate at the University of Leipzig and taught classical languages and literature. (College of William and Mary.)

A William and Mary publication of 1897 carried this advertisement for Harvard University. Harvard and William and Mary, the country's first- and second-oldest colleges respectively—though that order is constantly debated—were rivals in one sense but good friends in another. As President Ewell had sought unsuccessfully to save William and Mary before its closure in 1881, Harvard had served as a New England forum advocating public and federal support for the College. Other important support for William and Mary had come from historian Herbert Baxter Evans of Johns Hopkins University in Baltimore. Speaking of the Civil War reparations unsuccessfully sought by the College, he declared, "An institution which was once a beacon of learning and of political intelligence . . . has been suffered to decline by a nation which owes it an actual although paltry debt of $70,000." Reparations of $64,000 were finally paid in 1893. (College of William and Mary.)

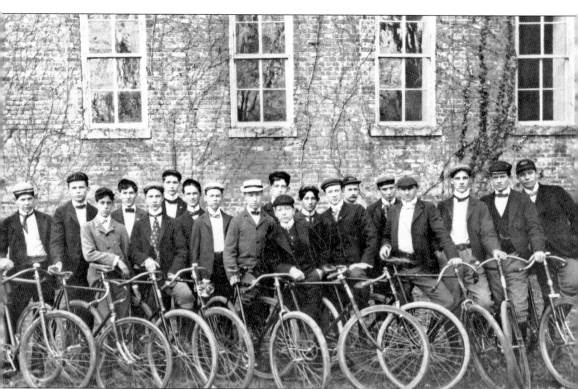

By the end of the 19th century, a semblance of the full experience of college life had returned to Williamsburg. The Bicycle Club of 1899 was among those campus organizations that helped, according to the yearbook the *Colonial Echo*, to bring people together. "By virtue of their association with each other, all unnecessary caste distinctions are broken down between Sophomore and Freshman, and a desirable esprit de corps is fostered among the whole student body." (College of William and Mary.)

Three

THE RESTORATION

Though a founding force of the nation, and teacher of many who had defined American democracy and ideals, William and Mary was, as of its full transfer to the state in 1906, no more than a small, struggling institution. With state support, by the mid-1920s the college had become a thriving place of academic and student life, but the Wren Building, still most often referred to as the Main Building, had fallen once again into disrepair. "We have held back for years on repair," Pres. Julian Chandler reported to the Board of Visitors on June 7, 1927. "The walls are crumbling on one side and something will have to be done." In 1931, the newly restored Wren Building celebrated the College's past and looked forward to its future. The back door, seen here *c.* 1931, opened beside a plaque that listed notable early alumni and offered a view of the vigorous westward expansion of the campus. (College of William and Mary.)

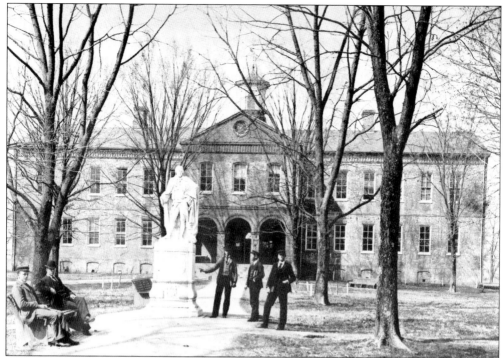

By the start of the 20th century, the list of less well-known alumni was almost as interesting as the list of the famous. Among those identified in the *College Monthly* of 1902 were several teachers and at least one school superintendent; a large number of family farmers; and A.D. Jordan, "who has a very lucrative position at the Pension Office in Washington." (Sargeant Memorial Room, Kirn Library, Norfolk.)

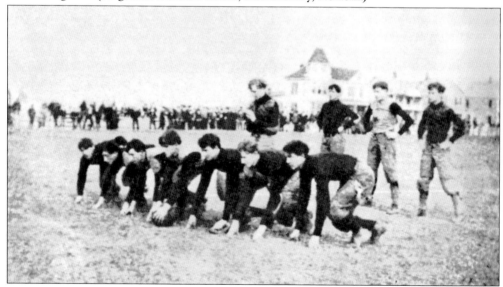

An expanding focus on athletics marked the opening of the century. Football had been played under various auspices in the 1890s. In 1904, the team, above, brought the College into larger competitive circles by reaching second place in the Virginia Intercollegiate Athletic Association's Eastern Division championship. (College of William and Mary.)

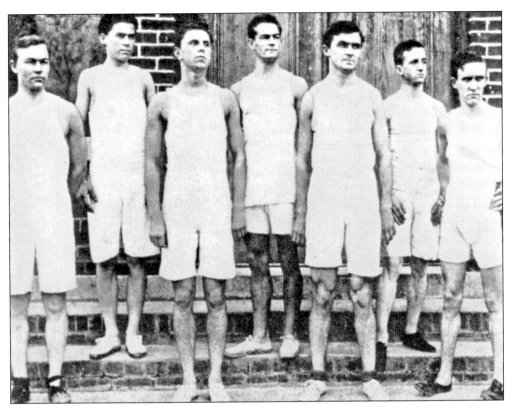

A new gymnasium was opened on the campus in 1901, in part to make the College more competitive with similar schools and to attract new students. Built at a cost of $5,300 between the Main Building and Jamestown Road, it was advertised as "one of the finest in the South." A competitive baseball team dated from 1894, and track was well represented by the team of 1908, above. The gymnastics team, right, is shown up in arms in 1905. Faculty kept tight control over the behavior of college athletes during these years. The baseball team of 1907 was nearly disbanded because of the use of profanity on the field. Student athletes were required to carry a 15-credit load, earning a C or higher on 10 hours and a D or higher on the remainder. (College of William and Mary.)

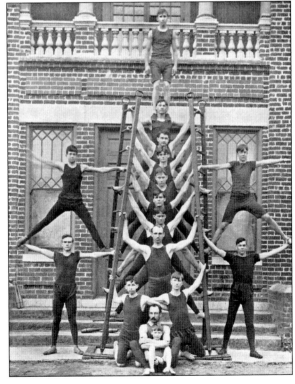

The master of arts class of 1904 was the College's first. Of its students, the yearbook, the *Colonial Echo*, said, "They realize the value of high ideals and of social service and appreciate educational efforts." In 1904, the College began the process that would transfer financial responsibility from the Board of Visitors to the state, and William and Mary became a state institution in 1906 as part of a large body of legislation that would upgrade all colleges and high schools in the Commonwealth of Virginia. (College of William and Mary.)

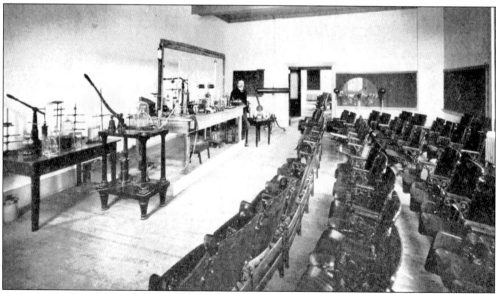

A physics laboratory, *c.* 1910, was located in Science Hall, which sat northwest of the Main Building. Completed in 1905 at a cost of $14,000, the building included facilities for the physics, chemistry, and biology departments. It was opened in an elaborate ceremony on April 27, 1906, that included speeches by the governor and the president of Johns Hopkins University. (College of William and Mary.)

THE FLAT HAT

VOL. I. COLLEGE OF WILLIAM AND MARY IN VIRGINIA No. 1

WILLIAM AND MARY BEGINS 219th YEAR

A Large Registration and Many Improvements

William and Mary, the time-honored alma mater of so many illustrious men, began its two hundred and nineteenth session on Thursday, September 21, under circumstances the most auspicious in its history. Until Saturday noon the total number of registrants was 175, an unusually large number so early in the session. Students, old and new, continue to arrive, and as we go to press there are many men about the campus who have not registered. Judging from past years it may be reasonably expected that fifty or more will enter the College before the close of the session.

Throughout the past summer many improvements have been made about the campus. Lecture rooms have been newly painted, worn out apparatus replaced by new, and the dormitories refurnished. Shortly after the opening of the session a committee from the Board of Visitors came here, and, after a thor-

Scrubs 0. Invincibles 0

On Saturday while the varsity was engaged in vainly trying to stem the tide among the green, vine clad hills of Albemarle, the Scrubs with head and nose knee deep in sand plunged, replunged and plunged again for the glory of alma mater on Cary Field. It was a case of an invincible force striking an immovable substance, for grovel as they might, sneeze and cough out signals no matter how quickly, neither side could score. The nearest approaches to it were when Geddy narrowly missed a drop kick and again when English made a fifty yard run only to be called back for stepping outside. Rowe for the scrubs came very near getting through the line once but something happened and the Invincibles got the ball. Cogbill played a beautiful game for the Invincibles. Healy played well for scrubs. Line up:

Scrubs.		Invincibles.
Healy	c	Mitchell
Wright, E. S.	r. g	Harrison
Nourse	r. t	Clements
Mayor	r. e	Witchley
Sommers	r. g	Wright, G.
Bane	l. t	Cox
Turner	l. e	Garth
Hall	f. b	Cogbill
Rowe	l. h	Thomas
Brooks	r. h	English
Jackson	q. b	Geddy

Annual Y. M. C. A. Reception

On the night of Tuesday, Sept. 26, the Y. M. C. A. tendered its annual reception to the new students and friends of this institution, and if the attendance and the evident good will be considered as indications, we predict a remarkable record for the Y. M. C. A. this year.

The reception was presided over by President H. W. Vaden aided by the Y. M. C. A. cabinet. Rev. Mr. Hoover, of the Baptist church, and the Rev. E. Ruffin Jones, of Bruton Parish church, delivered short and helpful talks, as did the President, Mr. Vaden, and Dr. Keeble. Dr. Wilson spoke on the Honor System, the pride of William and Mary, and Dr. Young in a brief talk brought forth the many-sidedness of college spirit.

Messrs. James and Deierhoi spoke in behalf of their literary societies, Philomathean and Phoenix respectively. During the course of the evening THE FLAT HAT was ably introduced by the editor-in-chief, William Kavanaugh Doty, and its aims and objects explained. Refreshments were served, and the pleasantest Y. M. C. A, reception ever held at William and Mary came to an end, having been materially brightened by the presence of the Institute teachers and students.

FOOTBALL TEAM AT REGULAR PRACTICE

New Coach Employing Best Methods

Football practice has been going on now for a week and the fellows ought to have gotten a line on the team by this time. One thing is evident, that green bunch that went out on Cary Field is being gotten into shape by Dr. Young about as fast as possible and while there is nothing very heavy about the team, they will, with grit and headwork render an account of themselves that William and Mary will be proud of.

This year a new factor has arisen which has caused quite a good deal of loss to the team. This factor is the ruling out of men in the "prep" classes. Heretofore they have been allowed to play and the men recruited from these lower ranks were the best on the team and this has been so, for years back. This year however they have been eliminated and as a consequence, many a hefty prospect roams over the campus, the cynosure of envious eyes. This ren-

The first edition of the student newspaper, the *Flat Hat*, appeared on October 3, 1911. Initially it was four pages published weekly on the subject of campus life and student activities. The *Richmond Times-Dispatch* called it "the liveliest thing in Williamsburg, which is saying a good deal." Faculty kept tight control over its contents and refused to circulate one of its first issues because of "certain opinions expressed in the editorials." It would go on to become a regular, and sometimes outspoken, voice on the campus, and is a quoted research source for this book. (College of William and Mary.)

The administration of Pres. Lyon Tyler saw the rapid development of badly needed college buildings. He was able to raise $20,000 in funds to match a library grant from the Carnegie Foundation, and the cornerstone for a new library was laid on April 13, 1908, Thomas Jefferson's birthday. It was 80 feet by 30 feet in size, and dedicated May 14, 1909. It would eventually become Tucker Hall, home of the Department of English. (College of William and Mary.)

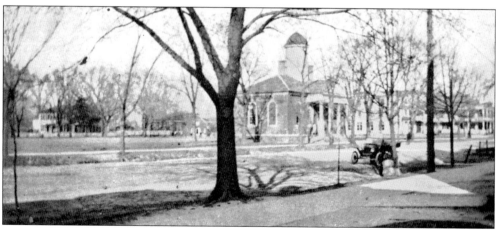

In 1915, Williamsburg's Duke of Gloucester Street was a quiet place, with one of its main occupants the Courthouse of 1770. The Colonial Inn, far right, offered rates starting at $2.50 and was the precursor of the Williamsburg Inn. By the end of World War I, land prices in Williamsburg had soared, and new homes and businesses were accompanied by a movie theater. (College of William and Mary.)

Social fraternities had been founded at the College before it closed in 1881 and were reestablished when the College reopened in 1888. There were not many fraternity members at the time of this 1915 montage. Fraternities had survived a faculty attempt to have them abolished, due to heavy drinking, in 1910, but had only 10 to 15 members each. (College of William and Mary.)

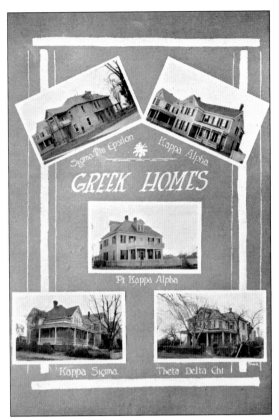

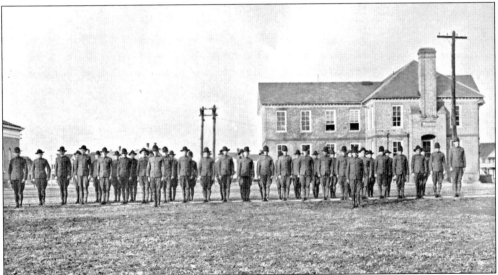

In World War I, college enrollment faced competition from the draft, and by 1917–1918 the number of students had decreased to 149 from a peak of 204 in 1905–1906. Adoption of the War Department's Student Army Training Corps (SATC) in the fall of 1918 brought 98 young men to the campus for military instruction that would prepare them for officer training camps. The program ended mid-semester, however, with the cease-fire of the war on November 11, 1918. (College of William and Mary.)

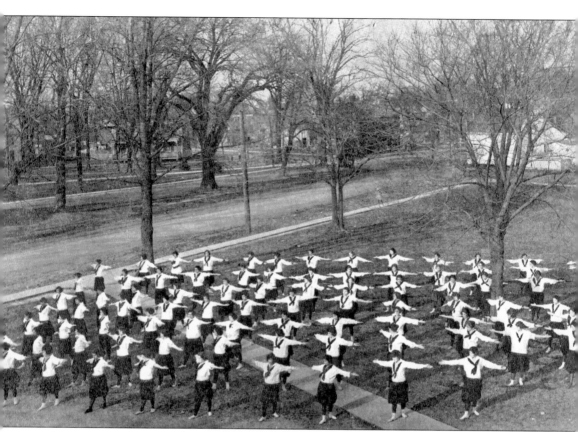

A women's physical training exercise fills the lawn on Richmond Road in 1921. Coeducation had been proposed and resisted since the 1880s. But President Tyler's sensibilities had led to the enrollment of his daughter at Wellesley College, and the role of his wife in Virginia's suffrage movement led him to believe that women would bring new life—and much-needed enrollment—to the College. Even the *Flat Hat* ventured that the school had been hindered by its traditions and did "things in terms of those who have preceded us Women will participate in activities and will rejuvenate them with better standards." Even so, the arrival of women on the campus on September 19, 1918, was called by some "Black Thursday." One student detractor noted that "the students weren't able to keep their minds on their studies because of the horrible women who were parading around in these short skirts." Many vowed they would not date the women, an idea that lasted for a few months. (College of William and Mary.)

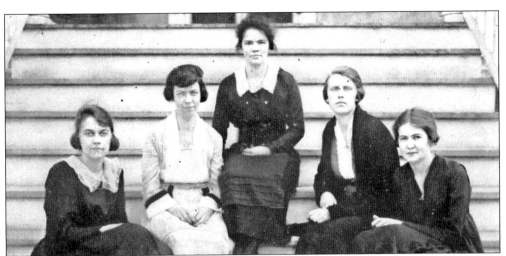

The Women's Student Council, formed in 1918, was led by Pres. Martha Barksdale, center. Others on the council, not identified by location, were Vice Pres. Janet Coleman, Secretary-Treasurer Catherine Dennis, and council members Ruth Conkey and Margaret Bridges. The purpose of the council was to "represent and further the best interests of the woman student body, to regulate the conduct of women under authority of the college, and to promote responsibility, loyalty, and self control." (College of William and Mary.)

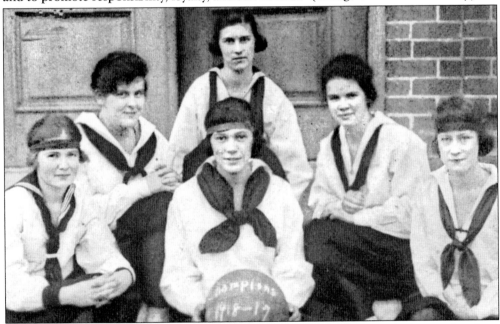

Women's Council president Martha Barksdale, second from right, worked immediately to establish an intercollegiate sports program for women, and would continue that work as an associate professor of physical education until 1966. The first basketball team, pictured, was set upon the court before 1920, and by 1925, women competed in hockey and tennis. Other basketball team members, noted by their playing positions but not located in this photograph, are Catherine Dennis (right forward), Alice Person (center), Ruth Harris (side center), Edna Reid (guard), and Celeste Ross (captain and guard). Martha Barksdale played left forward. (College of William and Mary.)

Two of the 36 members of the sophomore class of 1919 were women. The class yell was "Razzle, dazzle, dabble close / Husky curling Sophomores / Some are bright, some are dumb / We are the class of Twenty One." (College of William and Mary.)

An increasingly social campus led to the formation of clubs based on premises that ranged from the obvious to the obscure. The motto of the Walking Sticks in 1921 was "Never walk when you can ride." Inspiration for the clubs dated back to 1899, when the Swelled Heads Club, as an example, stated as its purpose "To take all compliments to ourselves." Required for admission was the wearing of a size-nine hat. (College of William and Mary.)

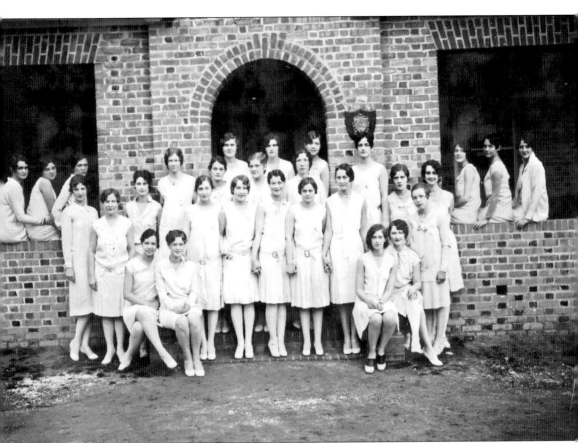

The Alpha Pi chapter of Kappa Delta was founded on the campus on October 23, 1928. In the 1920s and 1930s, just more than a third of students were members of fraternities and sororities. The organizations were responsible for much of their governance, though the college president had final say over the rules that applied to them. All fraternities had their own houses in the town, but sorority members could live only in houses controlled by the College. They were located on Richmond Road, near the President's House, the first of them occupied by Kappa Kappa Gamma in 1925. A Sorority Court of five houses was constructed with college funds between 1929 and 1931 on land between Richmond Road and Prince George Street. They provided a good source of rental income for the school. (College of William and Mary.)

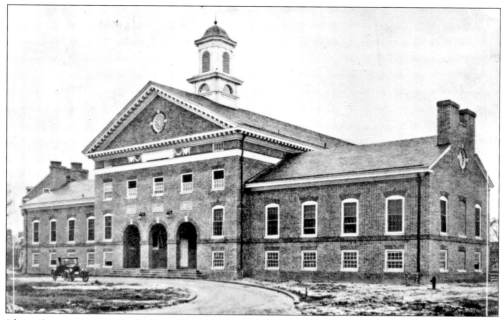

Blow Gymnasium was dedicated on June 9, 1925, in the name of Norfolk naval captain George Preston Blow. He had been the son and grandson of college alumni. Final cost of construction was $132,000, and the College advertised its campus as containing "one of the finest gymnasiums in the South." (College of William and Mary.)

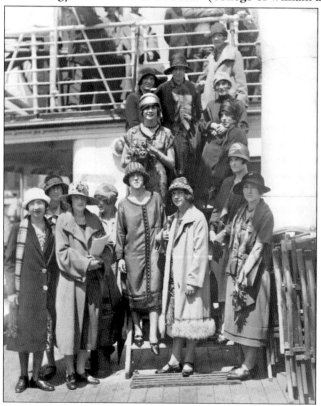

On June 13, 1925, the women of William and Mary were represented in a student trip back into the larger world of its origins. Sailing on the ship *Albania* to a summer session at the university of Toulouse are, from left to right, Minnie Binmore, Alice Person, Charlotte Shipman, Rena Luck, Margaret Bridges of the Women's Student Council, Katherine Schoolfield, Mary Bohannon, Etta Sawyer, Reita Day, and chaperone Mrs. White. (Earl Gregg Swem Library, College of William and Mary.)

The Flat Hat Club Society denoted itself as the oldest college organization in America, started in 1750, when it was named the FHC. It predated Phi Beta Kappa and included notable alumni like Thomas Jefferson on its rolls. Its officers, *c.* 1920, included Vice Pres. Earl Gregg Swem Jr., the son of Earl Gregg Swem, who was appointed as college librarian in 1920. (College of William and Mary.)

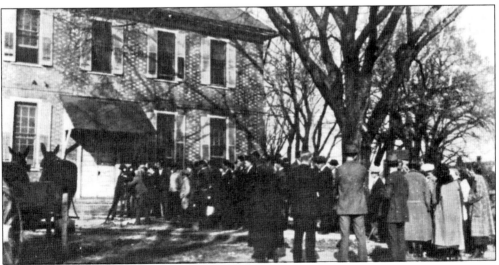

In 1924, filmmaker D.W. Griffith came to the campus to film *America*, a historical drama wrapped around a negligible love story. Lionel Barrymore played a womanizing British colonel, and the movie was most notable as Griffith's last silent film. The Brafferton is the scene of the picture shown here. To the right of the crew are students, faculty, and other spectators. (College of William and Mary.)

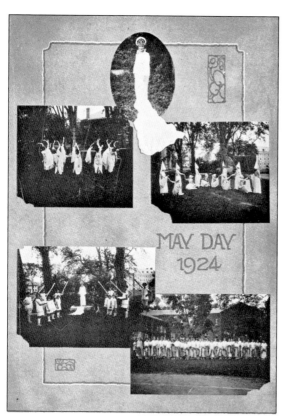

MAY DAY 1924

May Day was of more than the usual significance for the College of William and Mary. It had been on that date in 1699 that Virginia governor Francis Nicholson celebrated his partnership with Rev. James Blair in securing the founding of the College by declaring a day of celebration and rejoicing. He invited members of the Virginia General Assembly to attend as "Eye witnesses to one of His Majesties Royal bounties and favors." May Days remained occasions of music and theatre, as in 1924, left. The *Flat Hat* of April 26, 1929, reported that the celebration to take place on Thursday of the following week would be based on Chaucer's *Canterbury Tales*, with accompanying Greek and warrior dances. The May queen, chosen from four candidates named by the Women's Student Council, was council president and basketball player Elizabeth Duke. (College of William and Mary.)

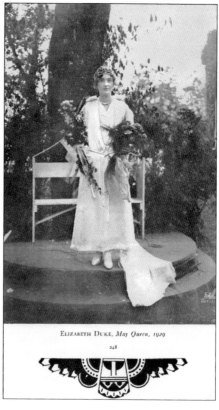

ELIZABETH DUKE, *May Queen, 1929*

248

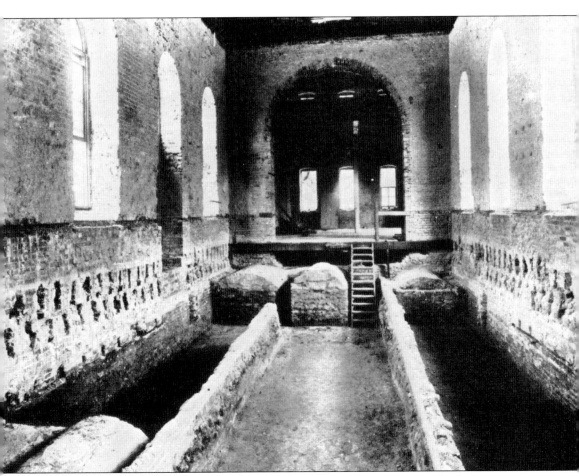

The restoration of the Wren Building, 1928–1931, seemed to symbolize both the sanctity of the college's origins and the need to renew itself for the future. During the restoration, the crypt under the chapel, seen here, was exposed to view. Among those buried here were Lord Botetourt; alumnus Peyton Randolph, president of the First Continental Congress; and two former college presidents. The work that would be done to restore both Colonial Williamsburg and the colonial campus of William and Mary was set in motion with a conversation between Rev. W. A. R. Goodwin, rector of Williamsburg's Bruton Parish Church, and American industrialist John D. Rockefeller Jr., as they walked down Duke of Gloucester Street one evening in March 1926. By the following year, a full restoration of the colonial town and much of the college campus was underway with initially unpublicized support from Rockefeller. (College of William and Mary.)

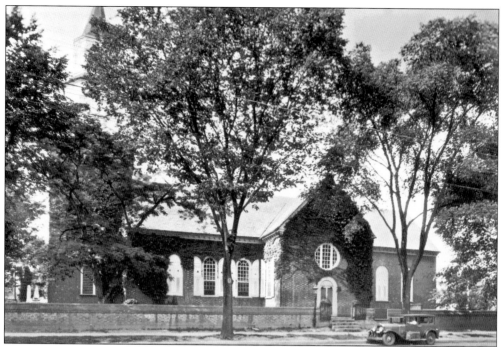

Williamsburg's Bruton Parish Church, above, photographed in 1932, had served as a touchstone between the parallel histories of the town and the College since 1683, and had been the place of worship for many of those who led the American Revolution. The Williamsburg Inn, below, shown in its opening year of 1937, was built under the supervision of John Jr. and Abby Aldrich Rockefeller as a culmination of the Williamsburg restoration. Elegant and expensive, it became important to college life both as an employer of students and as a venue for those who would play a part in the College's increasing international importance in following years. (Sargeant Memorial Room, Kirn Library, Norfolk.)

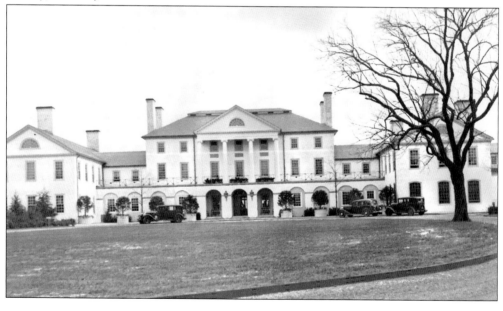

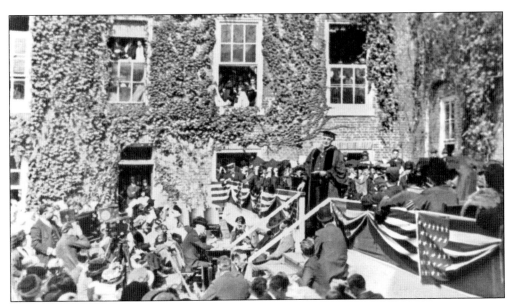

Within 150 miles of Washington, and spanning 300 years of American history, the College that had produced three presidents was often visited by their successors. The inauguration of College president J. A. C. Chandler on October 19, 1921, was cause for an address by U.S. president Warren G. Harding in the courtyard behind the Wren Building. A national press corps sits at his feet, newsreel cameras are rolling, and students hang out the windows. (College of William and Mary.)

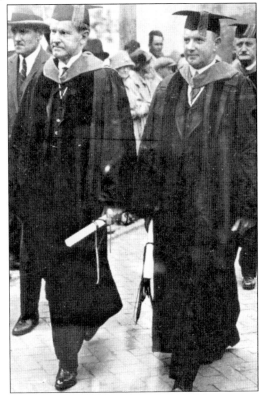

On May 15, 1926, Pres. Calvin Coolidge, left, attended a sesquicentennial celebration of Virginia's Resolution for Independence, the basis of the U.S. Declaration of Independence, with Gov. Harry Byrd, right. The ceremony took place in Wren Courtyard. College rector James Hardy Dillard follows behind Governor Byrd, far right. (College of William and Mary.)

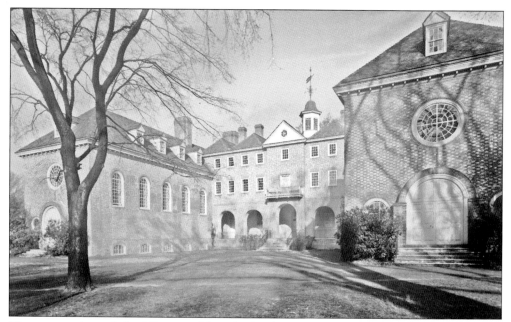

The restoration of the Wren Building had taken three years and was completed by September 13, 1931. It would be part of a wider program of restoration that included the President's House, completed by fall of 1931, followed by the beginning of work on the Brafferton. All work was accomplished by December 1932. (Library of Congress.)

John D. Rockefeller Jr., attends a 1937 college Christmas party in a powdered wig. Although the College made various efforts to retain its connection to the philanthropist, including the development of an endowment that might allow William and Mary to become independent of the Commonwealth of Virginia, they came to no results, though the Rockefeller Foundation would be a resource in later years. (Earl Gregg Swem Library, College of William and Mary.)

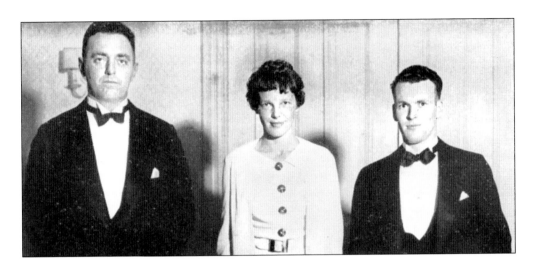

On March 17, 1932, aviatrix Amelia Earhart, center, addressed the College on the topic of "Women and Aviation." She is shown with Lt. Col. Earl Charles Popp, director of the aviation program, left, and student Barton Travers Hulse, right. The College was the first in the nation to incorporate aviation in its curriculum. In the program's first two years, it trained 70 students and produced 40 licensed aviators. Earhart's speech at Phi Beta Kappa Hall was attended by citizens from throughout the region. She stressed, according to the *Flat Hat*, "the importance of freedom for women in election of careers. She urged that any woman who was interested in aviation pursue and develop her interest with vigor and zeal." Student Minnie Cole Savage is shown in flight, bottom oval. Picture 2 is captioned "Colonel Popp testing a safety belt." (College of William and Mary.)

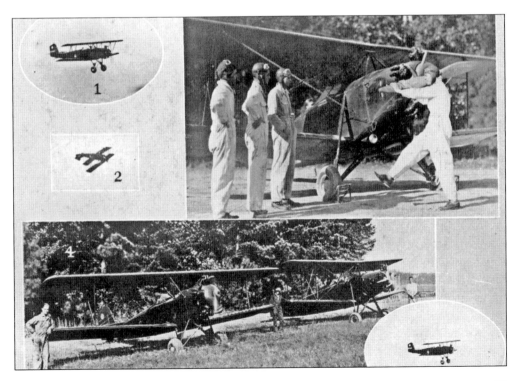

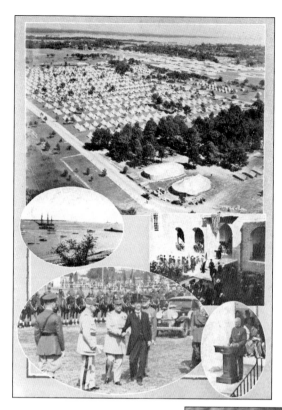

On October 19, 1931, Army general John Pershing, bottom right, dedicated a memorial tablet to French soldiers who had died in Williamsburg in the final days of the Revolutionary War. The event in Wren Courtyard was part of the sesquicentennial observance of the British defeat at Yorktown. Though not pictured here, Pres. Herbert Hoover was awarded an honorary degree by the College at a Yorktown luncheon on the same day. "No one," he said, "steps upon the soil of Virginia without inspiration from the part she has played in the winning of our liberties and the building of our institutions." (College of William and Mary.)

Pres. J. A. C. Chandler died in May, 1934, and John S. Bryan, second from right, was installed as president on October 20. The date also marked the formal opening of Colonial Williamsburg's restored Duke of Gloucester Street, and Pres. Franklin Delano Roosevelt, far left, attended both ceremonies. The event was broadcast nationally on radio and was covered in the newsreels of the day. (College of William and Mary.)

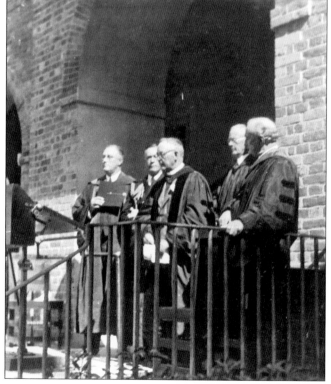

In response to the Great Depression, President Roosevelt created the Civilian Conservation Corps (CCC) with the twin goals of providing employment while developing and restoring public lands. Matoaka Park was a CCC project to build roads and trails in the forest properties of the College. It is pictured here in an advertisement for the College dated 1934. (College of William and Mary.)

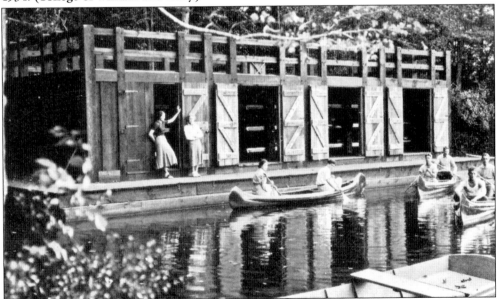

Matoaka Park covered 1,200 acres and was named after the Indian princess Matoaka, also known as Pocahontas, the daughter of the powerful Chief Powhatan. Lake Matoaka was constructed by colonists in the early 1700s and is one of the oldest man-made lakes in the New World. The boathouse, above, was constructed in 1935. In subsequent years, the park fell into disuse and was effectively abandoned in the 1950s. (College of William and Mary.)

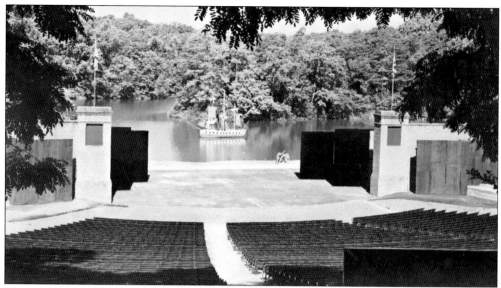

An amphitheater was constructed on the shores of Lake Matoaka in 1946 to present Paul Green's outdoor drama, *The Common Glory*, which opened in 1947. Produced by the Jamestown Corporation, the play "flips the pages of history," noted the Associated Press, "and brings to light beneath a starlit sky the stirring events that welded America into a nation." A summertime favorite of townspeople and tourists, the play ran for almost 30 years. (College of William and Mary.)

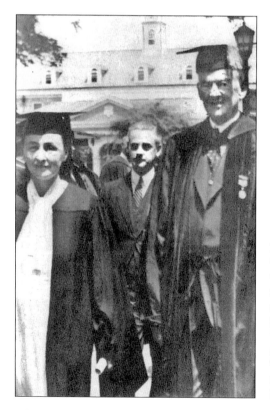

In 1938, artist Georgia O'Keeffe, shown with Pres. John Stewart Bryan, right, was given an honorary doctor of fine arts degree on the occasion of her first solo show in the American South. Her family had lived in Williamsburg from 1902 to 1909, and her two brothers were college alumni. She said, "The days in Williamsburg seem like a dream to me now." (College of William and Mary, Muscarelle Museum.)

Four

BUGLES AND BELLS

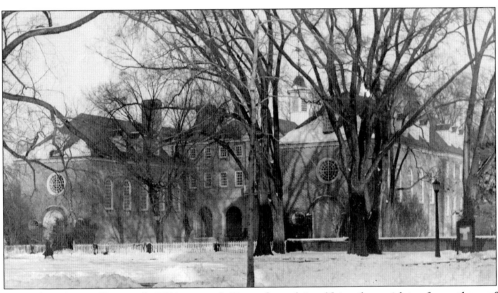

In 1940, the College of William and Mary found itself in the midst of another of the eras of challenge that seemed always to give renewed energy to the future. An effort to develop satellite divisions in Norfolk and Richmond would jeopardize the College's accreditation with the Association of American Universities (AAU) and create divisiveness about its mission and purpose. And, as had been the case during previous conflicts, World War II was threatening enrollment. The draft would begin to take college-aged students in mid-1941, and national focus on American entrance into the war in December of that year shifted attention from more academic pursuits. The challenge was met with the development of war-specific curricula and accelerated degree programs to reduce the months needed to obtain a degree. On February 8, 1943, the 250th anniversary of the founding of the College, Dr. John Edwin Pomfret became the new president. John Stewart Bryan, credited with having brought academic and financial stability to the school, was named college chancellor. (College of William and Mary.)

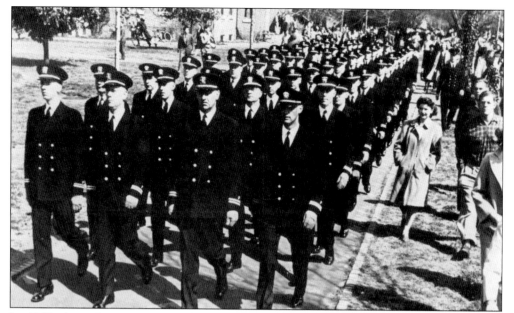

In 1943, the U.S. Navy stationed its chaplains' training school on the campus, located 50 miles from the naval base at Norfolk. The courses were eight weeks in length and intended to indoctrinate formerly civilian clergy who held naval commissions. The program provided much-needed revenue for the College in time of war. Civilian students were instructed to stand aside when the chaplains moved in parade. (College of William and Mary.)

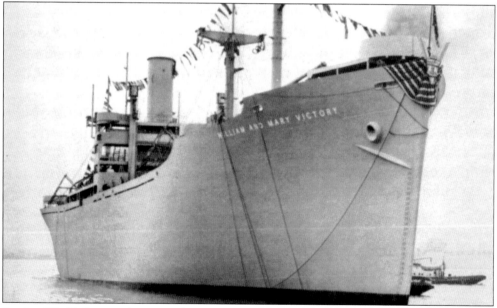

During World War II, the troopship SS *William and Mary Victory* was one of a number associated with the school. At 495 feet long with three masts and three decks, it was launched from Baltimore on April 25, 1945. A delegation of College officials and alumni were in attendance. Other college-related vessels were the Victory ships SS *James Blair*, SS *Lyon G. Tyler*, and the USS *Botetourt*. (College of William and Mary.)

In the midst of war, the 1942 football team was able to have a very good year. Its nine wins for the season included a victory over the University of Oklahoma and a tie with the U.S. Naval Academy, and the team won the year's Southern Conference championship. Subsequent war years saw a reduced athletic program. (College of William and Mary.)

The war, and its increased population pressure on the area from Williamsburg to the military facilities in and around Norfolk, led to an increased need for student medical care. Since its reopening in 1888, the College had paid notable attention to student health and was considered a leader in the field. (College of William and Mary.)

Earl Gregg Swem, photographed at left in 1942, and below in a portrait at the entrance to Swem Library in 1996, had been college librarian since the early days of the administration of J. A. C. Chandler and would become one of the most notable staff members in the school's history. With a grant from the Rockefeller Foundation in 1936, he had published *The Virginia Historical Index* of more than one million bibliographic entries. His working retirement in 1944 was used to put college archives in order and symbolized the transition that would be coming to the College postwar. By 1945, all but three faculty members had been appointed since 1930. (College of William and Mary.)

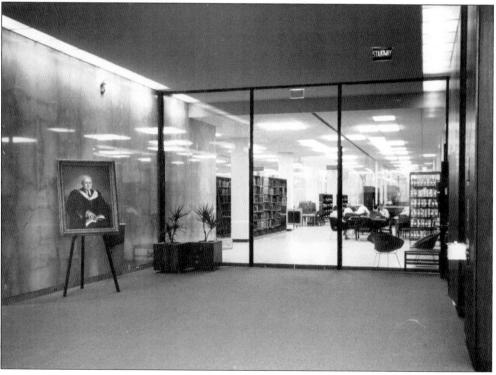

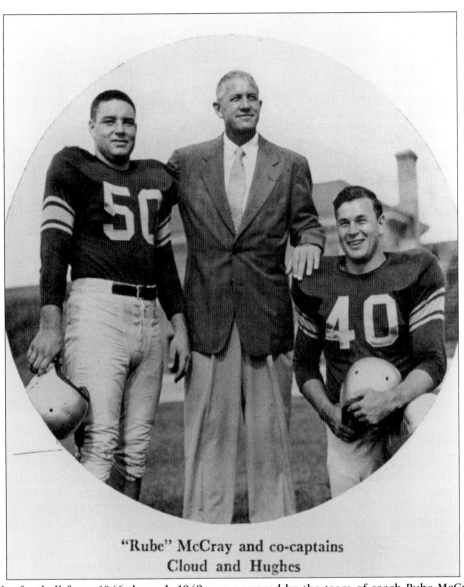

"Rube" McCray and co-captains
Cloud and Hughes

Tribe football from 1946 through 1948 was powered by the team of coach Rube McCray, Jack Cloud, left, and George Hughes, right. "Flying Jack Cloud" went on to a career with the Washington Redskins but returned to William and Mary as an assistant coach in 1954. In the homecoming of 1969, Cloud and 34 former college athletes were honored on the occasion of the creation of a Sports Hall of Fame. With few exceptions, the role of athletics in college history had been deemed very important, but there seemed to be a constant negotiation about that role in relation to academics. The 1950s would see a struggle between the Faculty Athletic Committee and Pres. A. D. Chandler over the rules, finances, and scheduling of athletics. One result was a deterioration of the school's intercollegiate athletic standings. In 1974, a comprehensive study of the condition of men's and women's athletics led to adoption by the Board of Visitors of recommendations by Pres. Thomas Graves that emphasized a renewed and ambitious intercollegiate athletic program, though one which deemphasized the notion of winning at any cost. (College of William and Mary.)

In 1948, the peacefulness of the Sunken Garden west of the Wren Building offered a respite between war and the years of new accomplishment that lay ahead. The garden was a 1920s enhancement of campus design that had been inspired by the gardens designed by Sir Christopher Wren in the 17th century for Chelsea Hospital in England. It was seen as fulfilling Thomas Jefferson's notions that the College should have places for rest and relaxation, and that "the College shall forever look upon the country." In the years leading up to World War II, the garden was used in springtime for college dances, often with alternating bands at either end of the garden. The Glenn Miller and Gene Krupa orchestras were among those who performed. The big-band era ended with the war. (College of William and Mary.)

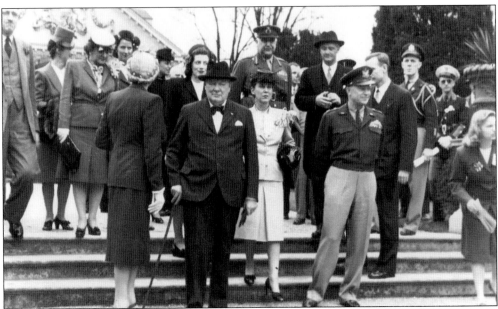

In the years following World War II, William and Mary began to develop a higher profile of participation in national and world events. In 1946, Gen. Dwight D. Eisenhower and Prime Minister Winston Churchill traveled together in the United States, stopping in Virginia on March 8. In a speech three days earlier at Westminster College in Fulton, Missouri, Churchill had coined the term "Iron Curtain" and warned of the coming spread of world Communism. Before coming to Williamsburg, shown above at the Governor's Palace, Churchill spoke before the Virginia General Assembly in Richmond, below, saying that he had accepted the invitation to speak because of "the primacy of the Virginia Assembly as the most ancient, law abiding body on the mainland of the Western Hemisphere." (College of William and Mary.)

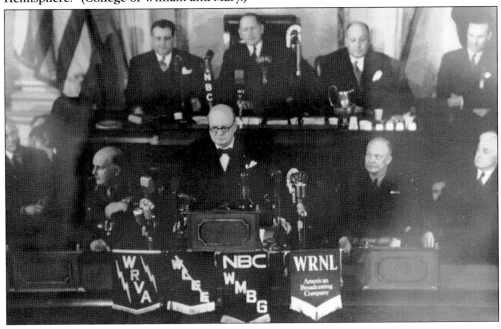

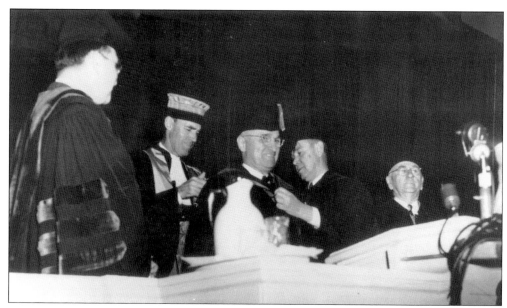

On April 2, 1948, Pres. Harry Truman sailed to Yorktown on the aptly named presidential yacht USS *Williamsburg* and motored to the nearby college to receive an honorary degree on the occasion of Canadian-American day. An article in the *Flat Hat* welcomed "a decent, honest, kind human being with common sense and self-discipline." He is shown receiving the hood from faculty marshals Ben McCary, left, and William Guy, right. Pres. John E. Pomfret stands at the far left. (College of William and Mary.)

Students are formally dressed in the lounge of Monroe men's dormitory in 1950. Opened in 1924, Monroe Hall sits on Richmond Road near Blow Gymnasium. It was designed and located to be symmetrical with Jefferson Hall, the women's dormitory on Jamestown Road. (College of William and Mary.)

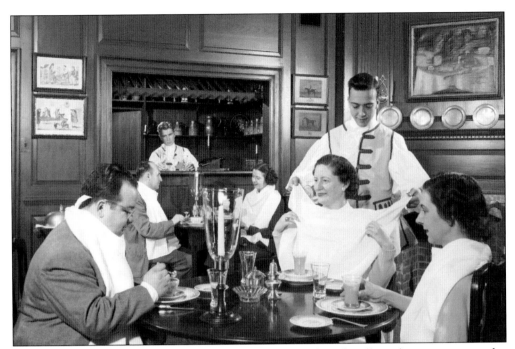

After the Rockefeller restoration and World War II, Colonial Williamsburg was a popular tourist destination and offered opportunities for student employment. King's Arms Tavern used student waiters dressed in the costumes of the 18th century. Its manager in the spring of 1951 was Gertrude Ball, second from right. (College of William and Mary.)

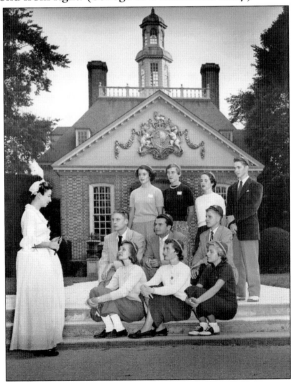

Hostess Alice Rice holds freshman orientation behind the Governor's Palace of Colonial Williamsburg in September 1950. New students, from left to right, are (first row) Martha Austin, Elizabeth Page Beck, and Helen Elizabeth Hesse; (second row) Ed Willis, Robert Diffin, and Kingsley Allen; (third row) Barbara Sievers, Barbara Sniffen, Joan McCarthey, and Peter Crenner. (Earl Gregg Swem Library, College of William and Mary.)

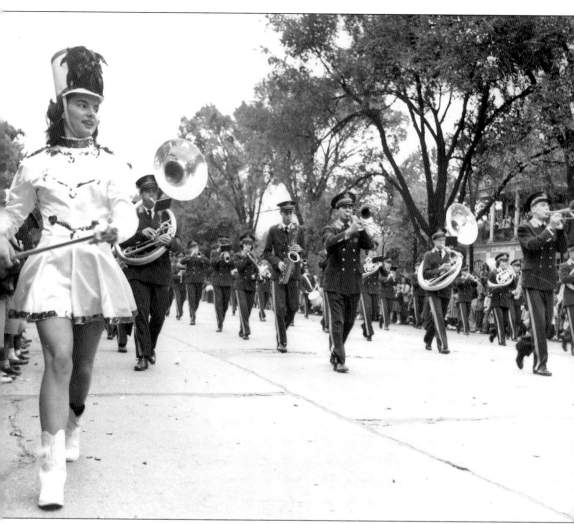

Majorette Mary McCloskey leads the William and Mary marching band in the homecoming parade on Duke of Gloucester Street, October 7, 1950. Discontinued during World War II, the band received only limited funding from the school in immediate postwar years. In 1949, it was invited to appear in the Winchester Apple Blossom Festival, a competition for school bands on the opposite end of the state. Students and faculty barely scraped together $200 to charter a bus to the event. Right off the bus, and in a pouring rain, the band won its first competition and placed third in another, winning $200 for its efforts. (College of William and Mary.)

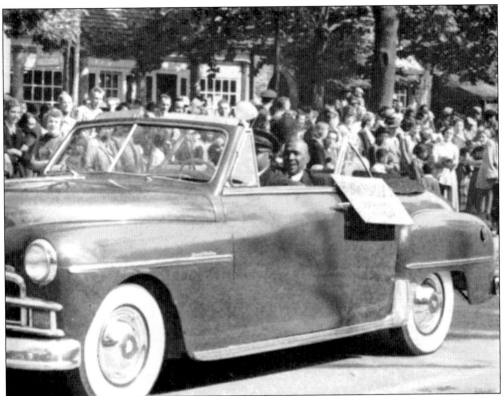

Honored in the homecoming parade of 1952 was Henry Billups, ringer of the college bell since the late 1800s. Billups's career had revolved around the care of the Wren Building and its yards, but more importantly over those years he had served as a mediating presence between students, faculty, and administration, equally comfortable and accessible to all. (College of William and Mary.)

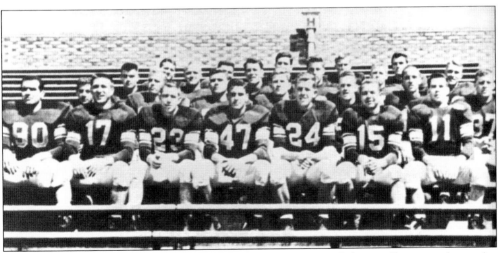

With just 25 members, the football team of 1953 was one of the smallest squads to play in college football that year, but it compiled a 5-4-1 record under coach Jackie Freeman. (College of William and Mary.)

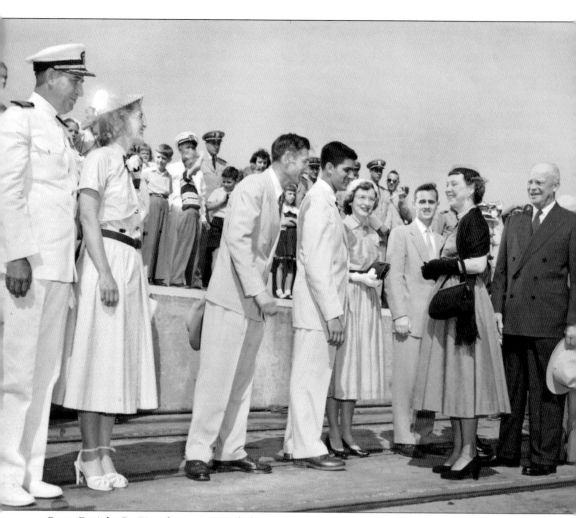

Pres. Dwight D. Eisenhower visited the campus on May 15, 1953, to receive an honorary doctor of laws degree, and to participate in the inauguration of new college president Alvin D. Chandler. From left to right are three unidentified people, senior class president Carmen Romeo, women's student government president Nancy Child, student body president John Dalton—who would become Virginia's governor in 1978 and was one of four Virginia governors to have graduated from the College—Mamie Eisenhower, and President Eisenhower. The inaugural invitation by the president of the College to the president of the nation was in keeping with Chandler's efforts to publicize the school nationally when possible, particularly with the prestige of those it was able to draw to the campus, including Chief Justice Earl Warren in 1954 and Queen Elizabeth II in 1957. (College of William and Mary.)

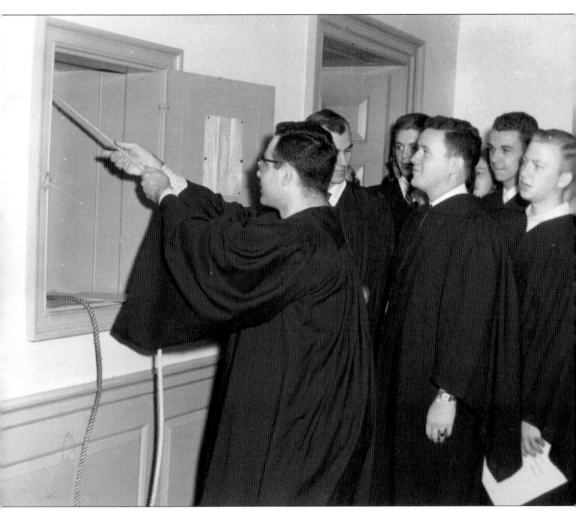

Members of the Class of 1954 ring the college bell on their last day at William and Mary, a traditional right of departing seniors. Since the early days of the College, it was rung on ceremonial occasions and to mark the days and hours. During World War I, it competed with the bugles of the Student Army Training Corps. "The bugles were not completely in tune with the college bell," said Janet Coleman Kimbrough, class of 1921, "and the professors for the most part ignored the bugles and went by the bell, and if the bell rang a little early, that was all right, but if the bell was a little later than the bugle, that was very upsetting because the army people were furious if the students didn't get right up with the bugle and march out, and the professors were very much upset if they did." (College of William and Mary.)

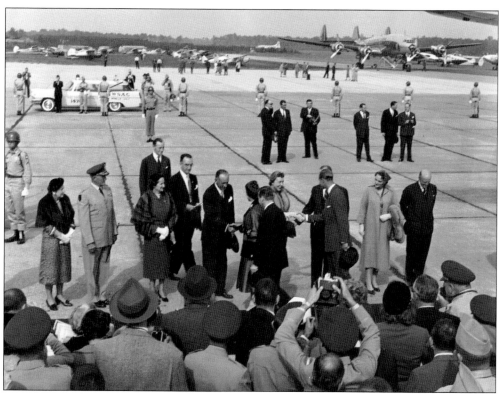

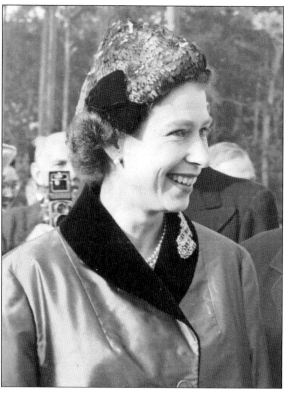

Two hundred sixty-four years after the founding of a college named in honor of King William and Queen Mary, a reigning British monarch arrived at nearby Patrick Henry Airport in Newport News to inspect the campus for the first time on October 16, 1957. "The official Red Carpet," reported the *Flat Hat* of the arrival of Queen Elizabeth II and her husband, Prince Phillip, "was rolled from her reviewing stand at the airport and the flags of 10 members of the British Commonwealth were unfurled." The visit was in observance of the 350th anniversary of the settlement of Jamestown. After a visit to Jamestown, "the Queen and her party drove to William and Mary, where she had a brief tea in the President's House and then toured the Wren Building." (College of William and Mary.)

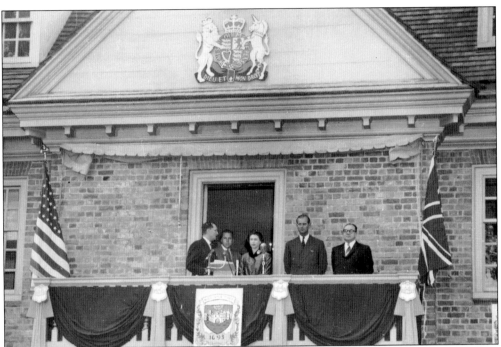

Speaking from the Wren balcony, Queen Elizabeth said, "we should cherish this part of our joint history, and take pride in the close association between learning in the two countries." She was "very proud of the fact that this college educated so many founders of this nation." The queen "was charming," according to alumnus and eventual college official James Kelly. "She charmed the campus and charmed Virginia. Virginia once again swore allegiance to the crown." (College of William and Mary.)

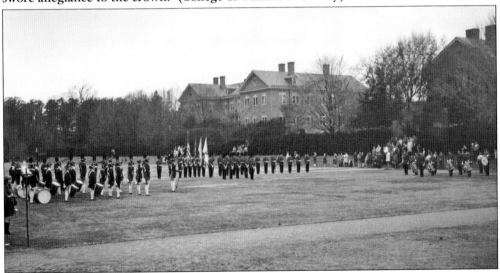

The influence of royalty on the campus extended to the traditional Reserve Officer Training Corps (ROTC), in which a select group of ROTC members constituted the Queen's Guard, seen marching in the Sunken Garden in 1968. The guard was named in recognition of the patronage of three queens: Mary II, Anne, and Elizabeth II, who would continue to play a role in college life after her visit in 1957. (College of William and Mary.)

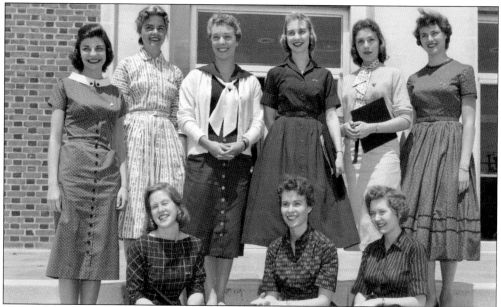

The Virginia Gamma chapter of Mortar Board recognized college women for scholarship, leadership and service. Its William and Mary members in 1958–1959 were, from left to right, (seated) Beverly Harris, Susan Boorman, and Patricia Anne Westcott; (standing) Clarissa Harrison, Terry Walker, Nancy Simmons, Karen Thomas, Penny Witzman, and Joan English. (College of William and Mary.)

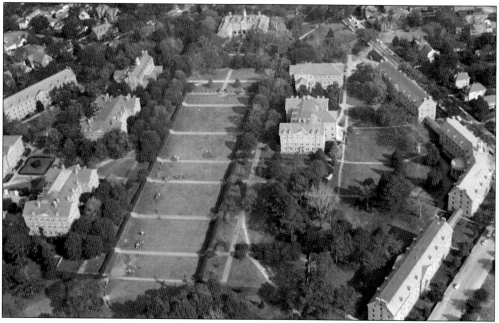

An aerial view of the traditional campus, c. 1960, shows the importance of the Sunken Garden as a common area between the hardworking buildings of the College. Extending out to the south (right) of the Wren Building are, from top to bottom, Ewell Hall and Washington Hall. To the north are Tucker, Tyler, and James Blair Halls. (College of William and Mary.)

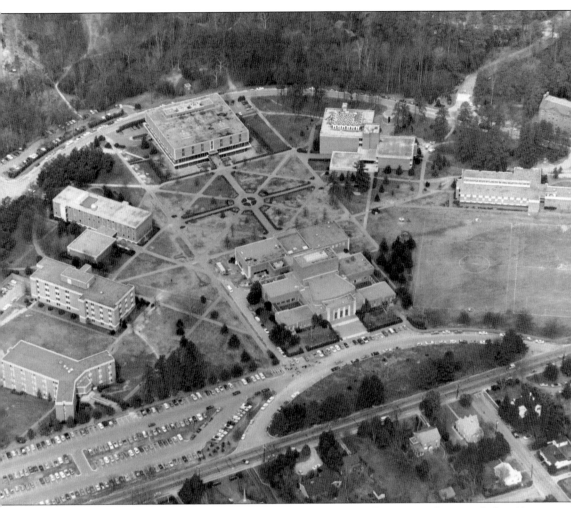

On August 16, 1960, Davis Y. Paschall became the new college president, and the 10 following years would be a time of academic, enrollment, and physical expansion—all of it exemplified by the construction of the "New Campus" at a cost of $40 million. Though the physical facilities of the New Campus were needed, a document associated with the development of campus design guidelines in 2003 would assert that "With the construction of a new campus in the 1960s, a dichotomy arose between the architectural character of the Old Campus and the modernist expressions of the New Campus. The development of the western portions of the campus, into which the College has expanded since that time, has further contributed to a sense of fragmentation." Seen from the sky, the buildings on the left are, from bottom to top, academic buildings Morton Hall, Jones Hall, and Small Physical Laboratory. In the center foreground is Phi Beta Kappa Memorial Hall, and Swem Library is at the arc of Campus Drive. On the right, from left to right, are Millington and Rogers Halls. (College of William and Mary.)

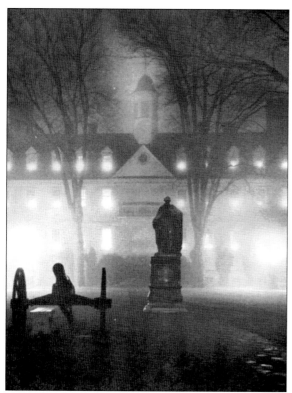

A nighttime photograph of the Wren Building in the 1950s, left, evokes the history and beauty of the College Yard. And as President Paschall pursued the expansion of the New Campus, he worked to hold the Old Campus in deserved respect. In 1961, the Wren was designated a National Historic Landmark, an event captured in this Interior Department photograph of the courtyard in which President Paschall, left, is given the landmark plaque by Elbert Cox, regional director of DOI. (College of William and Mary.)

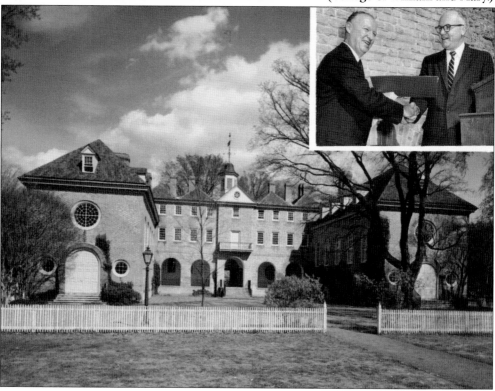

Civil rights activist Charles Evers, brother of Medgar Evers, speaks on campus, *c.* 1970. As in many institutions of the South, the acceptance of racial integration at the time of Medgar Evers's assassination in 1963 was just beginning, although it had been taking place in graduate programs at William and Mary since 1951. Undergraduate integration began slowly in the 1960s, and a scholarship fund in honor of Martin Luther King Jr. was initiated in 1968. By 1971, an African American student organization was in place with 40 members. The college catalogue stated for the first time that the school was open to all qualified students, but the development of a black student body moved slowly through the 1970s. Black administrators were hired, one as an assistant dean of admissions. Under Pres. Thomas Graves, and accompanied by changing federal and state laws, procedures were put in place to increase black student enrollment, which reached three percent by 1983. Hiring of black faculty through those years was hampered by noncompetitive salary levels. (College of William and Mary.)

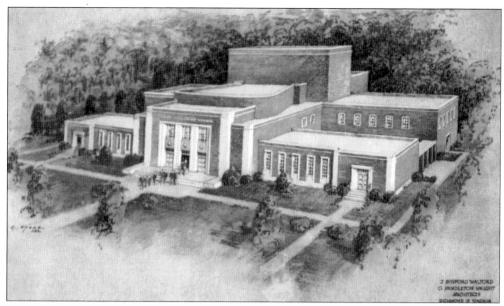

The Phi Beta Kappa Memorial Hall of 1957, the first building of the New Campus, served as a central auditorium, with related facilities. John D. Rockefeller Jr. and the Alpha of Virginia Chapter of PBK supported construction of the new building. It became, and remained into the 21st century, a place where the College could touch base with the larger surrounding community. (College of William and Mary.)

Photographs of the square and modern buildings of the New Campus often attempted to see the structures in interesting ways, as in this picture of the Adair Gymnasium for women. It was constructed in 1963 and named for alumna Cornelia Storrs Adair of the class of 1923. (College of William and Mary.)

Though functional and utilitarian, the new buildings allowed the occasional demonstrations of beauty that may not have been possible in the smaller buildings of the past, as in this sorority dance of 1963 held in the Campus Center. (College of William and Mary.)

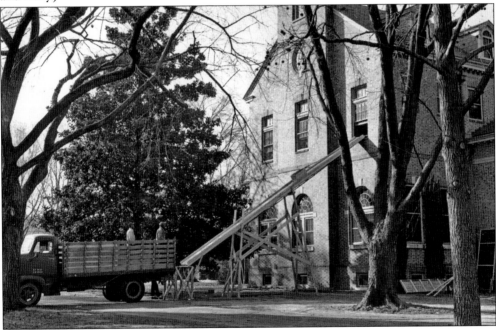

In 1966, the contents of the old library, built in 1908 with funds from the Carnegie Foundation and situated west of the Wren Building, were removed to the new and badly needed Earl Gregg Swem Library. The new library was seen as the keystone of the New Campus. The College Yard statue of Lord Botetourt was moved to the library's gallery, and a dedication took place on Charter Day of 1966. (Earl Gregg Swem Library, College of William and Mary.)

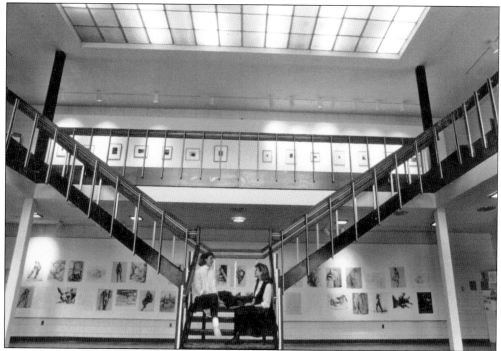

The Robert Andrews Hall of Fine Arts was added to the back of Phi Beta Kappa Memorial Hall in 1967. A professor at the College from 1777 until 1804, Andrews taught moral philosophy and mathematics and, as part of the reorganization of the curriculum in 1779, he became the first American college professor to offer instruction in the fine arts. (College of William and Mary.)

In 1962, the Virginia Fisheries Laboratory became the Virginia Institute of Marine Science (VIMS), offering doctoral programs to students of William and Mary and the University of Virginia. The Gloucester Point facility, located at the mouth of the York River on the Chesapeake Bay, was the central resource for the science that underlay the region's important fishing industries. VIMS came fully under the College umbrella in 1979. (College of William and Mary.)

In 1970, the women of William and Mary represented both the traditional beauty and the brains and leadership of campus life. While President Paschall planted a kiss on the cheek of homecoming queen Gail Granger, at right, Nancy Terrill, below left, became the first woman elected as president of the student body. The college mace was carried by the head of the student assembly at all official convocations. Four feet long and made of sterling silver, it was given to the College by alumni and students on the 230th anniversary of the royal charter in 1923. It was crafted of 12 segments, each depicting events in college history. (College of William and Mary.)

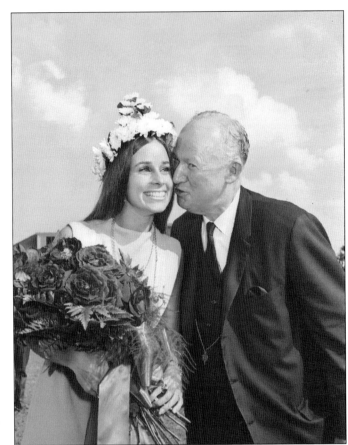

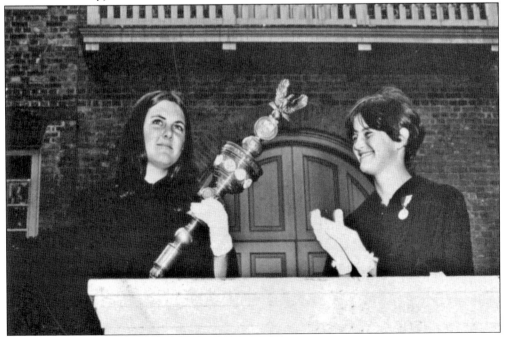

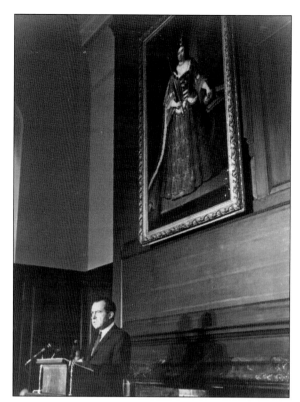

Presidential candidate Richard M. Nixon gave an address in the Wren Building on October 2, 1968. According to the *Flat Hat*, "He joked that he had no intention of entering the debate between William and Mary and Harvard for the distinction of being the oldest university in the country because he wanted no debates with Harvard graduates after the experiences of 1960." He spoke beneath the portrait of Queen Anne, successor to King William III. (College of William and Mary.)

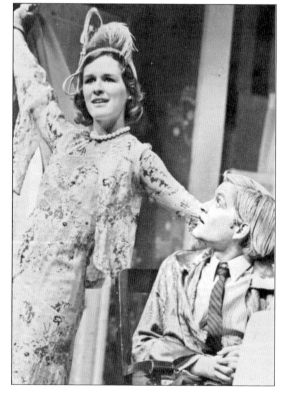

In 1972, student actress Glenn Wade, left, played the role of Alice to Jeff West's Tony, right, in *You Can't Take It with You*. Of the actress, the *Flat Hat* wrote, "She manages to portray a variety of vastly different characters without being placed in a particular category or being tagged with restricting labels. Will Glenn Wade make it as a professional? The odds are never good . . . talented college grads are a dime a dozen." (College of William and Mary.)

Five

THE SUNDIAL

The campus sundial first appeared on a wooden pedestal in front of the President's House in 1815. It was removed and sequestered for protection during the Civil War. In 1912, it was given a Tuscan column and rededicated as a gift from the staff of the *Flat Hat* on the occasion of the newspaper's first year. In 1971, a replica was placed at the center of the quadrangle in front of Swem Library "In honor of Davis Young Paschall, president August 16, 1960–August 31, 1971, developer of the new campus and the college to modern university status. From the old campus to the new—a challenging heritage in time." In the 21st century, it is a starting point and meeting place at the center of the campus that might seem ironically timeless. (College of William and Mary.)

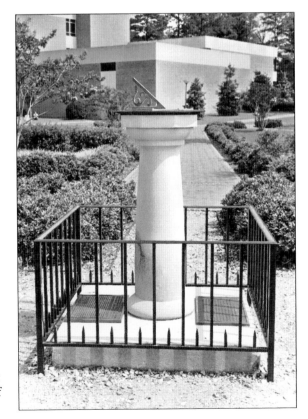

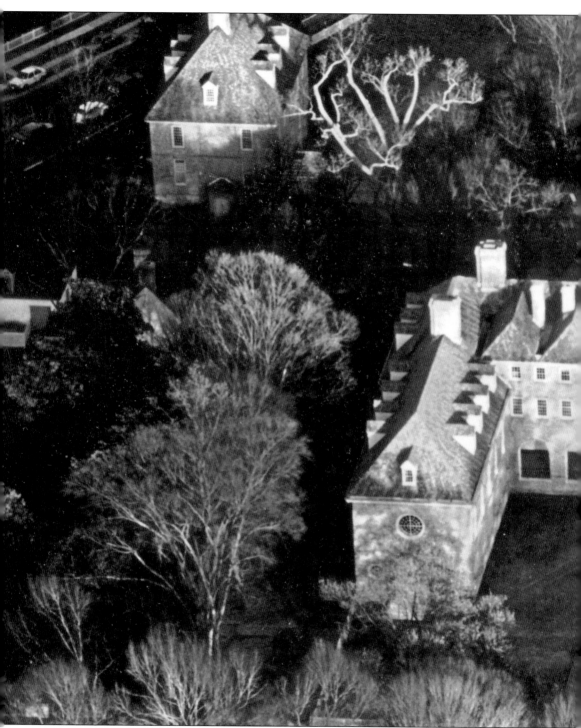

The Wren Building is seen in a bird's-eye view on a fall day, c. 1980. With the naming of the Wren Building as a National Historic Landmark in 1961, the College of William and Mary and the Colonial Williamsburg Foundation joined forces to restore, refurbish, and air condition the building. The Wren, called "the soul of the College," would continue to

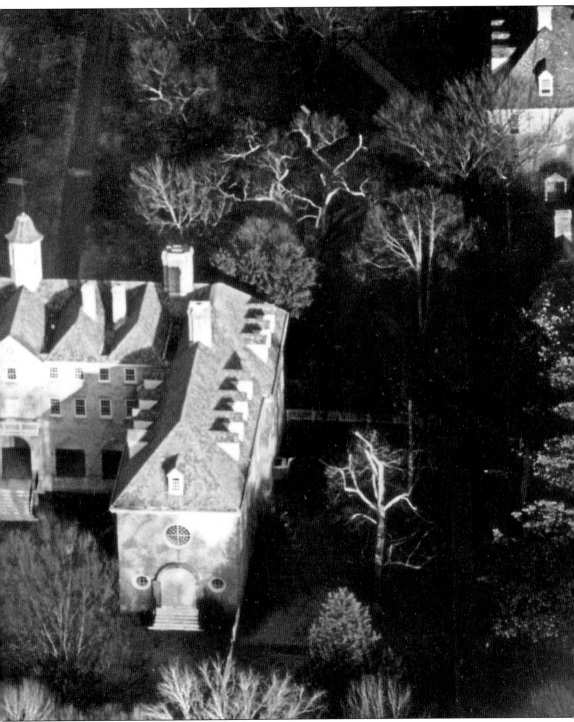

be used for all of the signal activities of William and Mary: education, the meeting place of ideas and the telling of history, and a home for music and the rituals of faith. (College of William and Mary.)

Thomas Jefferson reappeared on the lawn between Washington and McGlothlin-Street Halls in 1992, his return to the campus a gift from the University of Virginia. After studying at the College from 1760 to 1762, Jefferson read law with George Wythe, a fellow signer of the Declaration of Independence. Wythe later became professor of law at William and Mary, and when he became disenchanted with the College and departed, Jefferson's

affection seemed to take similar course. He went on to found the University of Virginia in Charlottesville in 1819. One interpretation of history holds that, as Jefferson sought to create his university, he was not averse to the idea of moving funding from his struggling alma mater to his new ideal. (College of William and Mary.)

Lord Botetourt maintains his watch, the Brafferton over his shoulder, in the fall of 1997. Upon his death in 1770, he was called "the best of governors and the best of men." The statue was commissioned by the Virginia General Assembly at a cost of 700 guineas. It was placed in the colonial capitol building in Williamsburg but fell into neglect when the capital was moved to Richmond. In 1796, a noted architect wrote, "A beautiful Marble statue of Lord Botetourt . . . is deprived of its head and mutilated in many respects." It

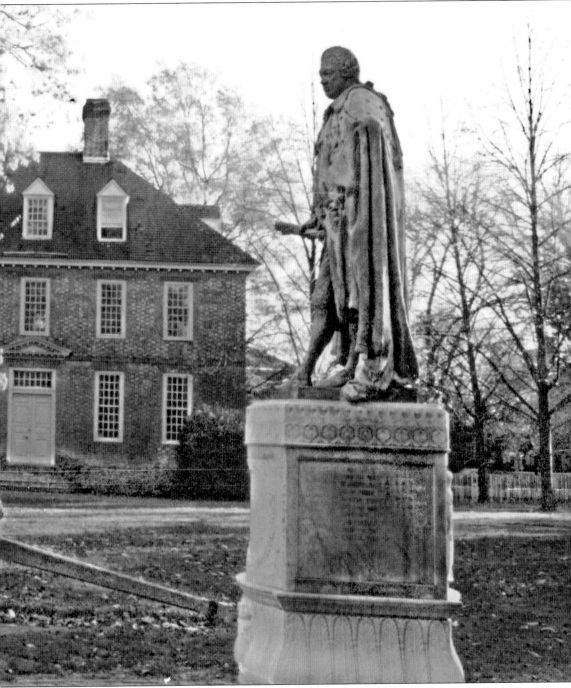

was purchased by the College and stood in front of the Wren Building for most of the next 157 years. By 1958, it had become too old and weathered for the elements and was moved to storage and later installed in Swem Library. The statue pictured is a contemporary interpretation by W&M alumnus Gordon Kray of the 18th-century original. (College of William and Mary.)

Nearly identical in design to the Brafferton, the President's House has been the residence of all but one of the College's presidents. It was used by French officers during the Revolutionary War, was badly damaged by fire in 1781, and became headquarters for Union Forces in the Civil War. (College of William and Mary.)

The architecture of the Wren Building offers those who use it a variety of patterns of light and shadows. The round windows of its wings may be comfortable places to wrap oneself up with a book, though students are discouraged from doing so. (College of William and Mary.)

Though the campus had always been a place of foliage, lawns, and ravines, the Vision Plan of 2003 sought to bring a consistent use of nature to the college environment. "Canopy tree species," it decreed, "should be located on both sides of the walk at regular intervals and with a consistent setback from the walk edge." (College of William and Mary.)

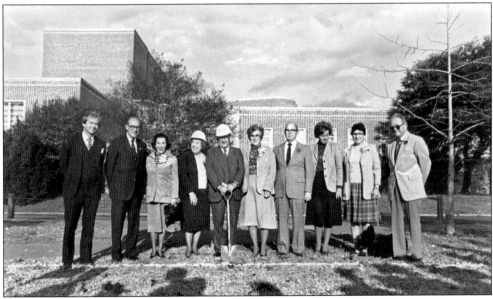

In November 1981, ground was broken for the Muscarelle Museum of Art. It houses the art and artifacts of a 300-year college history and provides a gallery for other important exhibitions, most notably of the works of Georgia O'Keeffe in 2003 (see page 56). From left to right are architect Carlton Abbott, Pres. Thomas A. Graves, Gertrude Perrin, Margaret and Joseph L. Muscarelle, Jeanne and Gilbert Kinnamon, Zoë Graves, Lucy and Fred Herman, and their terrier Duffy. (College of William and Mary, Muscarelle Museum.)

Students take a brisk walk past James Blair Hall in December 1999. Constructed in 1935 as the Marshall-Wythe Building with funding from the Public Works Administration, it has gone on to serve both academic and administrative functions. (College of William and Mary.)

The college campus, known for its wide variety of trees and shrubs, is a favorite stop of garden and arbor tourists. The snows of a winter day in 1979 offer highlights to a mulberry tree, foreground; two cryptomeria, far right; several American elms, center; a tree of heaven, left against Barrett Hall; and several varieties of boxwood. (College of William and Mary.)

90

A lonely walker passes between the Wren Courtyard and the Sunken Garden in the winter of 1963. Though a large, open space, the Garden gives added emphasis to the centrality of the Wren Building in campus life and history. (College of William and Mary.)

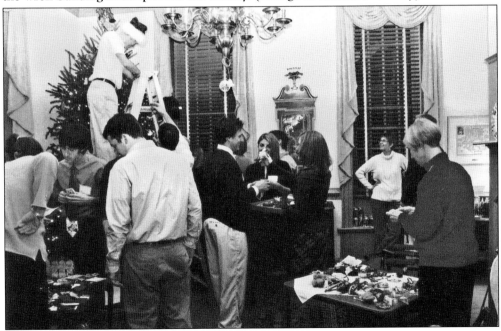

The President's House is decorated for Christmas in 2004. The students are president's aides, drawn from sophomore to graduate levels to talk with the president on a monthly basis and to serve in official functions. Anne Sullivan, far right, is wife of Pres. Timothy Sullivan. (College of William and Mary.)

By unspoken tradition, it is not supposed to snow as far south as Williamsburg, and when it does most everything else comes to a stop. Student Greg Barber, writing in the *Flat Hat* of January 31, 1997, described the effect of an overnight snowfall: "Williamsburg commuters get up early to start their morning drive and say 'Well, crud. I'm from the South so I'm obligated to drive poorly in the snow.' Tourists . . . will rush to wake their spouses and children and shout 'Look, kids! It's colonial snow! This is the same snow Thomas Jefferson used to see. Oh, the history, the history!' . . . And W&M students? The true beauty of a Williamsburg snowstorm is that we won't get up at all." (College of William and Mary.)

A dusting of winter snow surprises a palm tree outside of Ewell Hall. Planted by biology professor J. T. Baldwin, it has staked an unverified claim as the northernmost palm tree in North America. Surrounding boxwoods are grown from slips originating in the gardens of Versailles in France. (College of William and Mary.)

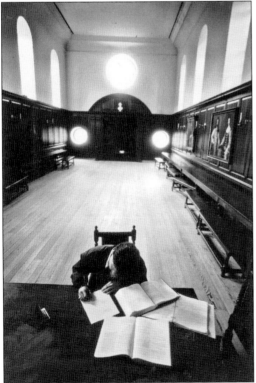

Winter light through the windows accompanies the quiet of the Wren Building's Great Hall as a place to study and write, as King William and Queen Mary watch from the paneled wall. (College of William and Mary.)

Crim Dell waits for the end of winter in 2003. Planning for the New Campus of the 1960s saw the area at the end of the Sunken Garden as the potential site for the new Swem Library, but others resisted the idea. The bridge was a gift to the College from the class of 1964. It was dedicated by President Paschall, "That one may walk in beauty, discover the serenity of the quiet moment, and dispel the shadows." The dell, named for John W. H. Crim, a student from 1897 to 1903 and an assistant U.S. attorney general, became a popular place for recreation and meeting, but the pond was sometimes viewed by students with skepticism and derision, and occasionally referred to in humorous articles in the *Flat Hat* as a cesspool, or something similar. There was speculation as late as 2006 that its fish might be feral. (College of William and Mary.)

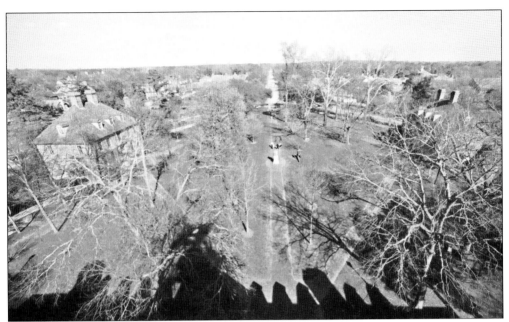

Spring comes to the College Yard and courses down Duke of Gloucester Street into Colonial Williamsburg. The oldest building on campus, the Wren, was also the tallest at the top of its cupola as it entered the new millennium. The picture was taken by Associate Vice President for Public Affairs Bill Walker from the highest scaffolding constructed during a "Wrenovation" in 2000. (College of William and Mary.)

President Paschall's attempt to blend beauty with modernization included the entrance to the New Campus across from Crim Dell, known by some as "Paschall's Gateway." The plaque between the trees depicts a phoenix, the symbol of the school's many cycles of decline and rejuvenation. (College of William and Mary.)

A less elaborate college entrance is made more colorful by the tulips of spring. A 2003 campus master plan would reaffirm the guiding principles of the College's development. They would require walkable distances between all living and learning spaces, the preservation of open green space, and the first campus-wide standard for buildings and landscape. (College of William and Mary.)

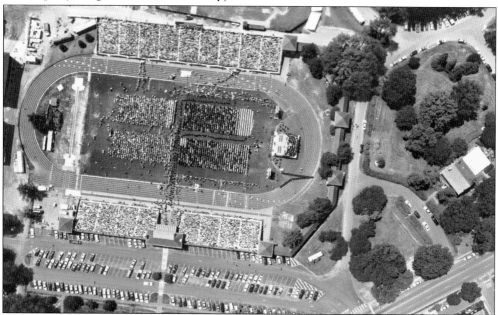

Commencement was held in the Zable Stadium at Cary Field on June 16, 1993, a very hot day. The field, another facility underwritten by the Public Works Administration in 1935, was a necessity that accompanied the increased emphasis on competitive athletics at the time. Future commencements would be held indoors to avoid the inhospitable heat of the stadium. (College of William and Mary.)

Six

THE ENERGY OF YOUTH

A team of graduate students and faculty of the College of William and Mary's Virginia Institute of Marine Science (VIMS) float together for a group photograph in the Florida Keys in 2003. The work they have been doing is a natural extension of the environmental sensibilities that had motivated Sir Robert Boyle at the end of the 17th century. Boyle was a chemist and student of nature, and these VIMS scientists are in the middle of 10 days of saturation diving—living and working on the sea floor for an extended period—while they study the effect of reef shapes and currents on coral bleaching. With its proximity to the Atlantic Ocean and the nation's largest natural estuary, the Chesapeake Bay, the College uses the surrounding waters as an opportunity for research and teaching. Floating from left to right in front of *Aquarius*, the world's only permanent underwater laboratory, are VIMS graduate students Kristen Delano and Jo Gascoigne, Dr. Mark Patterson, and graduate student Janet Nestlerode. (College of William and Mary, Virginia Institute of Marine Science.)

The William and Mary Alumni Association, founded as the Society of the Alumni on July 4, 1842, is the sixth-oldest alumni association in the country. Its headquarters today is a renovated and expanded 19th-century brick farmhouse that was acquired by the College in 1928. Before becoming the Alumni House in 1972, the structure was used as a residence for several generations of college students, faculty, and veterans of World War II. After renovation and expansion, it was rededicated during homecoming celebrations in 1997 as a venue for alumni, visitors, and events. The Alumni House includes the Davis Y. Paschall Library, left, named in honor of the 22nd college president. Paschall's tenure saw the development of the New Campus, the expansion of academics and enrollment, and designation of the school as a university by the State Council on Higher Education in 1968. At the start of the 21st century, 31 percent of reporting alumni had gone on to careers in business and economics, 15 percent in law, 12 percent in education, 7 percent in technology, 6 percent in medicine and health sciences, and 3 percent in the arts. Other fields included library science, and travel and recreation. (College of William and Mary.)

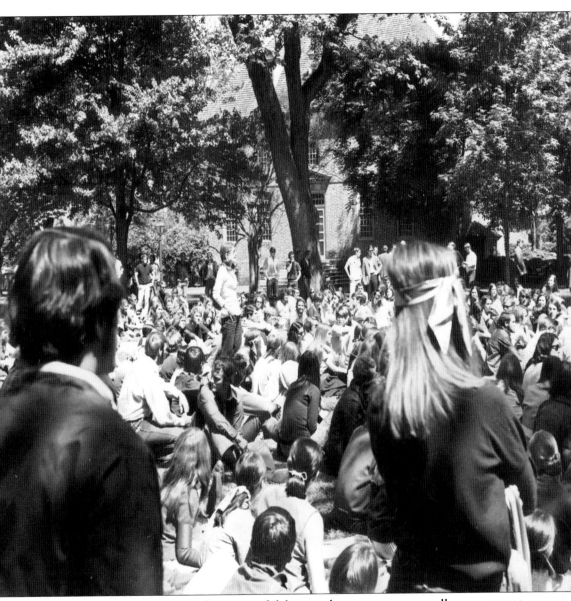

In 1970, the Vietnam War was the cause of debate and unrest on many college campuses, including William and Mary. On May 7, a nonviolent protest was held in the College Yard in response to the shooting deaths of students at Kent State University in Ohio three days earlier. Related *Flat Hat* editorials depict campus attitudes of the times. Noting that campus demonstrations had taken place both in support of peace and of those fighting in Vietnam, one said that they would lead to more reflective thought about the war. "Contrary to popular opinion, demonstrating concern for the war in Vietnam is not the 'in' thing on the William and Mary Campus." Another noted a Free College movement on the campus that sought practical experience in dealing with "the problems presented by life in the 20th century—LSD, the war, population control The crust which has been forming over the College of William and Mary for the past 275 years is slowly crumbling under the pressure of a youthful, genuine quest for knowledge." (Earl Gregg Swem Library, College of William and Mary.)

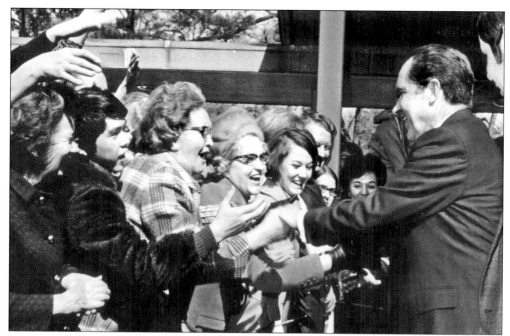

Pres. Richard Nixon, above, returned to Williamsburg in March 1971 to speak to the National Conference on the Judiciary. The visit coincided with the Counter-Culture Conference on Peace and Justice that brought poet Allen Ginsberg and activist Rennie Davis to the campus. (College of William and Mary.)

In 1970, the athletics building, William and Mary Hall, was still under construction when its basketball court made its debut in a game with the University of North Carolina. Heat and permanent seating had not yet been installed. Fans sat on folding chairs, and North Carolina's bus was brought into the arena to serve as a warm refuge for the team during halftime. Despite the hardship, North Carolina was able to pull off a 101-72 victory. (College of William and Mary.)

In 1976, Republican president Gerald Ford sought reelection in a contest with Democratic governor Jimmy Carter of Georgia. The two candidates engaged in a nationally broadcast debate from Phi Beta Kappa Hall on October 22. The moderator was journalist Barbara Walters. "It is particularly appropriate," she said in opening, "that in this bicentennial year we meet on these grounds to hear this debate. Two hundred years ago, five William and Mary students met at nearby Raleigh Tavern to form Phi Beta Kappa, a fraternity designed, they wrote, to search out and dispel the clouds of falsehood by debating without reserve the issues of the day. In that spirit of debate, without reserve, to dispel the clouds of falsehood, gentlemen, let us proceed." Then-representative Ford had visited the campus as its commencement speaker in 1968. "This historic Christopher Wren Building," he said, "the oldest academic building in the country, which has been sacked by British redcoats, commandeered by French officers, burned by Union cavalrymen and fortified by Federal Canoneers, has never yet fallen to the student body." (College of William and Mary.)

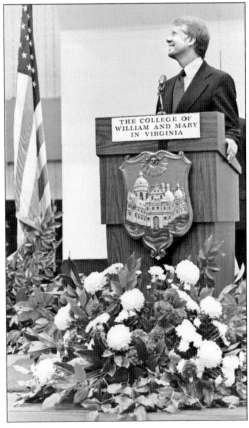

For the first century and a half of the College's history, meetings of the faculty and the Board of Visitors were held in the Blue Room on the second floor of the Wren Building. This historic room is still used today for special meetings of the board when key decisions, such as the choice of college president, are made or ratified. The room is also used by students for the defense of doctoral dissertations and master's and honors theses. (College of William and Mary.)

A wood-sided station wagon carries alumni M. Carl Andrews, front window, and Howard Smith, back window, of the Order of the White Jacket in this undated picture. The order was formed c. 1970 to provide fraternity among students of William and Mary supporting themselves as waiters, waitresses, and food-service workers at the College and in local restaurants. The work was hard and valuable to the larger community. Membership in the order is considered a badge of honor. (College of William and Mary.)

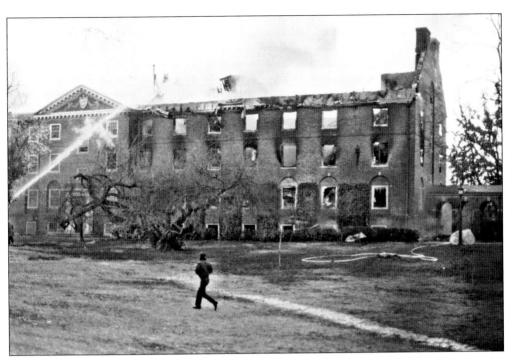

On January 20, 1983, Jefferson Hall was gutted by fire that started with a first-floor refrigerator. One hundred eighty students were driven into a 14-degree night, but none were injured. Recovery and restoration would be completed by January 1995. Jefferson had opened in 1921 as a dormitory that accommodated 125 women students, with apartments for female faculty members and a gymnasium and pool in the basement. As had been the case with the Wren Building fire of 1859, the college community and the town joined forces to continue classes without interruption, with temporary housing made available in Williamsburg homes and motels. (College of William and Mary.)

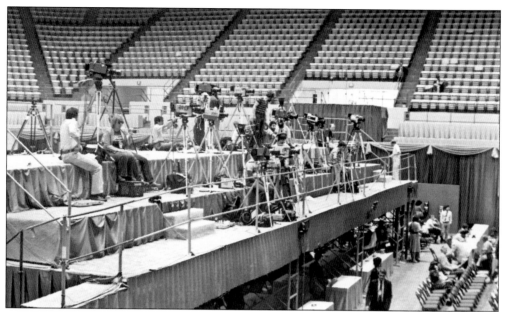

In May 1983, William and Mary Hall served as the international media center for the Summit of Industrialized Nations, which brought together President Reagan of the United States, President Chirac of France, and other world leaders. The summit provided an opportunity for the College to further its exposure to the international community and was attended by journalists from all parts of the world. Peter Jennings of ABC News took time to meet with Zoë Graves, to his left, a fellow native of Canada, and, from left to right, with her husband and College president Thomas Graves and Muscarelle Museum benefactors Doris and Ralph Lamberson. President Graves served from 1971 to 1985, bringing growth of academics and involvement of students in decision-making, though not always without conflict between faculty and administration. (College of William and Mary.)

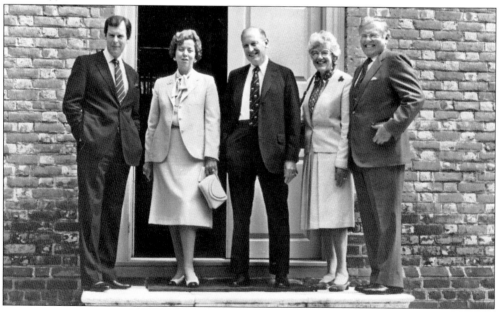

Professor of geology Dr. Gerald Johnson and students excavate a whale fossil in nearby Hampton in the 1990s. The College is surrounded by the nation's first settlements and on geology associated with the formation of the Chesapeake Bay by a meteor collision 35 million years ago. Geologic research in the late 20th century would range from studies of the bay impact structure to the provenance of ballast stone in a sunken British collier off Yorktown. (College of William and Mary.)

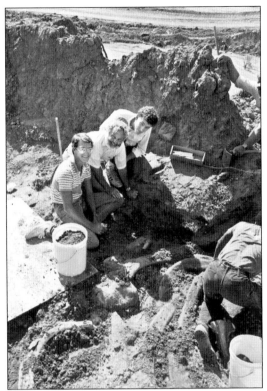

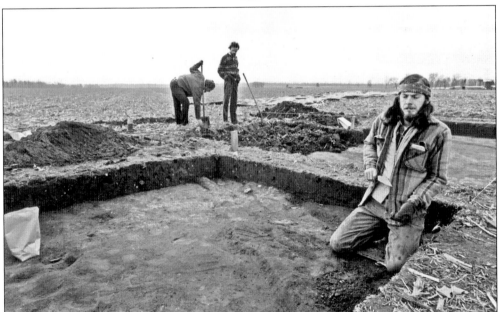

Anthropology professor Norman Barka, standing center, works with students and researchers on the excavation of Flowerdew Hundred, a historic plantation near Hopewell, Virginia, c. 1990. Dating to 1619, it is one of many historically important sites within less than 100 miles of the College, including Historic Jamestowne, which would continue to yield new information into the 21st century. (College of William and Mary.)

Grand marshall for the homecoming parade of 1984 was the actress Linda Lavin (fourth from left), class of 1959. Interviewed in the *Flat Hat*, she noted differences in campus life since her graduation. "The changes are clear and considerable. We had 10 p.m. curfew weekdays and 11 p.m. on weekends. We couldn't have any cars and there were no coed dorms. Students now are more in touch with their feelings than we were." (College of William and Mary.)

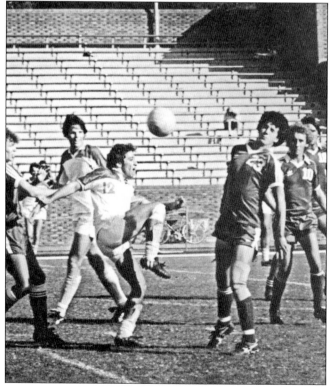

Psychology major Jon Stuart Leibowitz (center), class of 1984, was a star soccer player on campus and coached the sport at Gloucester High School. The 1983 team achieved a 14-6-2 record that "Leibo," as he was known, attributed in the *Colonial Echo* to the team's "unity and closeness." He would return to the College to give the commencement address of 2004 as comedian Jon Stewart. "Thank you Mr. President," he said. "I had forgotten how crushingly dull these ceremonies are. Thank you." (College of William and Mary.)

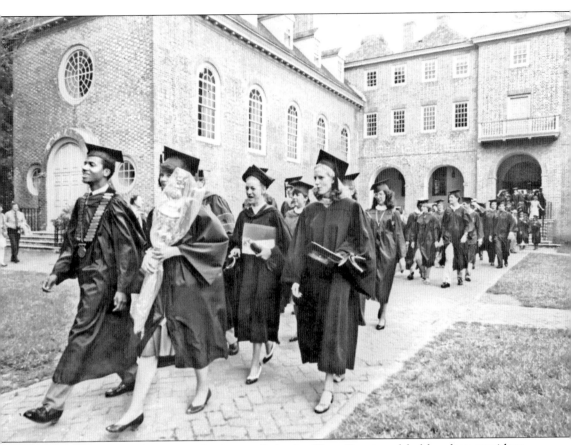

The class of 1985 takes its graduation walk in the Wren Courtyard led by class president Anthony McNeal. Upon assuming leadership of the Student Association as a junior, McNeal worked toward policy positions on affirmative action and financial aid. His term also saw increased student activism with the state General Assembly, especially in relation to drinking-age legislation. Another member of the class of 1985 was Michael Powell, who would go on to become chairman of the Federal Communications Commission and be elected rector of the College in 2006. "William and Mary is the source of my values," he said. "It gave me the foundation to be in a position to hold such an esteemed position. It's also a journey that gave me my wife and children. This may help you understand why I am so moved." (College of William and Mary.)

Retiring chief justice of the U.S. Supreme Court Warren Burger was installed as the 20th chancellor of the college in 1987. His role as chancellor would be active and hands-on. In 1953, the College's Department of Jurisprudence had become the Marshall-Wythe School of Law, named after former student John Marshall, the fourth chief justice of the Supreme Court, and his professor George Wythe. Justice Burger had called for the establishment of a National Center for State Courts, which was located in Williamsburg in 1973 with programmatic ties to Marshall-Wythe. Its mission is the modernization of court procedures and administrations worldwide. Chancellor Burger, seen here talking with students in the center's moot courtroom, was a frequent presence in Marshall-Wythe classrooms and in student gatherings. Described as always complimentary and respectful of individual students, he would be willing to debate even his own decisions as chief justice. He served as chancellor until 1993. (College of William and Mary.)

In the last quarter of the 20th century, the National Center for State Courts (NCSC), above, worked toward the improvement of jury system management, promoted technological innovation, and developed programs to increase public confidence in the courts. Other NCSC programs ranged from initiatives on racial equality to domestic violence. In reporting prior to the internationally sensationalized 1995 trial of O. J. Simpson, a star football player accused of murdering his wife and a friend, the McGlothlin Courtroom at Marshall-Wythe, below, was used by ABC News in a demonstration of the state of courtroom technology of the time. The courtroom was the centerpiece of a four-nation conference on the impact of court technology in 1998 cosponsored by the William and Mary Institute of Bill of Rights Law and the American Bar Association's sections of Criminal Justice and Litigation. (College of William and Mary.)

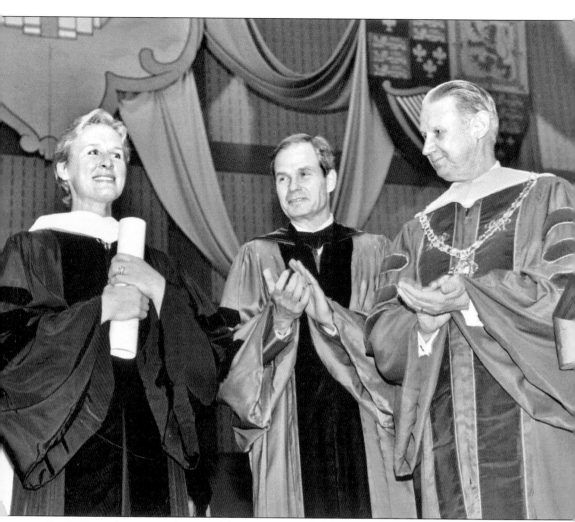

In 1989, an honorary doctor of fine arts degree was given to actress Glenn Close, class of 1974 (see page 80), by Pres. Paul Verkuil, center, and Rector Hays Watkins. In a speech to the graduating class of that year, she advised that they "Be brave and strong. And just go out there and do it." Paul Verkuil, class of 1961, was president from 1985 to 1992. His stated focus would be on the expansion of graduate and research programs in a way that would not detract from the school's undergraduate mission. He also believed in the power of celebration at the historic college and initiated ambitious plans for the coming tercentenary of 1993, but surprised the campus with the announcement of his resignation to become the president and chief operating officer of the American Automobile Association. The picture was taken by Jim Gleason, who served as an instructor and the College's principal photographer for 20 years. Four of his students would win Pulitzer Prizes for their work. (College of William and Mary.)

The years immediately following 1986 were used for filling-in, expansion, and renovation of the campus, culminating in the opening of a new University Center, above, in 1993. Perhaps inspired by tales of a group of eagles that had appeared one day above the football field at halftime, the statue *Soaring Eagles* by alumnus David Turner, far right, class of 1983, was a gift to the University Center in 1994. Pres. Tim Sullivan, far left, stands next to Chancellor Professor of Biology Emeritus Mitchell Byrd, a pioneer in wildlife preservation in Virginia whose work would lead to the establishment at the College of the Center for Conservation Biology in 1992. (College of William and Mary.)

On the occasion of the tercentenary celebrations of 1993, the Society of the Alumni of the College of William and Mary published *The College of William and Mary: A History*. It was written by, left to right, history faculty member Richard B. Sherman, regional historian Susan H. Godson, and history faculty members Thad W. Tate and Ludwell H. Johnson. Author Helen C. Walker is not pictured. In a preface, the authors said they believed "that it is important to understand the almost unceasing struggle of the College for survival in its first two centuries and, after permanence was essentially assured, the succession of efforts to define and redefine its purposes and character." The authors admitted, further, that at the outset they had underestimated the task that would result in two volumes and 982 pages. "The College has had a long and unusually complex history." Their work has served as the resource of final authority for this book when possible. (College of William and Mary.)

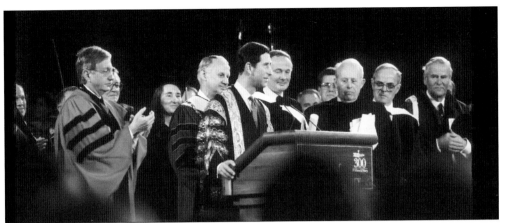

The tercentenary year saw the reestablishment of bonds between the College and its British origins. On February 13, 1993, Charter Day was celebrated with a visit from Charles, Prince of Wales, above. "Together," he said, "we have much to be proud of." On stage with the prince are Pres. Timothy J. Sullivan, far left; and behind the prince, from left to right, Rector Hays T. Watkins; Sir Robin Renwick, Great Britain's ambassador to the United States; and Virginia state senator Hunter B. Andrews, class of 1942. The latter two received honorary degrees during the ceremony. The visit was the second by Prince Charles. In 1981, he had received the College's first Honorary Fellowship, spoken to a capacity audience at Phi Beta Kappa Hall, and was honored in a luncheon, below, that included Chesapeake Bay crab in the Great Hall of the Wren Building. (College of William and Mary.)

Pres. Timothy J. Sullivan greets Queen Elizabeth II during a tercentenary visit to London on June 3, 1993. Sullivan, class of 1966, became president on June 1, 1992. He managed to increase both the school's endowment and its research grant funding by 300 percent each. Annual admissions applications increased by 40 percent (to 10,000) during his tenure. All of his attributes, according to rector Susan A. Magill on the announcement of his retirement in 2004, could be summarized in one word: "Excellence." (College of William and Mary.)

A wedding takes place in Wren Chapel in 1993. The bride and groom, unidentified, are among hundreds of alumni couples, and a number of college presidents and their brides, to have been married or to renew vows at its altar. Similar in design to many of the collegiate chapels of Great Britain, its paneling is of native pine and walnut. Its English, 18th-century chamber organ is on loan from the Colonial Williamsburg Foundation. (College of William and Mary.)

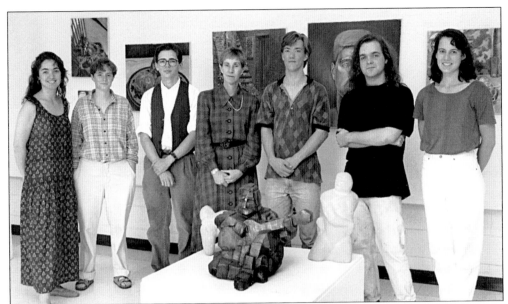

The President's Collection of Faculty and Student Art was established in 1993 to purchase the best expression of college artists for display throughout the campus. On May 13 of that year, Anne Sullivan, center, class of 1966 and wife of Pres. Timothy Sullivan, poses with selling artists. From left to right are Lisa Filipi, Lisa Boone, Mark Taggart, David Jones, Daniel Pitman, and Anne Murphy. Artist Jeremy Somer is not shown. (College of William and Mary.)

In 1994, the Board of Visitors honored seven retiring faculty members who represented the reach and variety of college academics. Pres. Timothy J. Sullivan is shown, far right. Also pictured from left to right are (seated) Mary Joy Archer (professor of kinesiology) and Joanne Basso Funigiello (professor of modern languages and literature); (standing) rector James Brinkley, Eric O. Ayisi (professor of anthropology), Richard Sherman (professor of history), Bradner W. Coursen (professor of biology), and M. Boyd Coyner (professor of history). (College of William and Mary.)

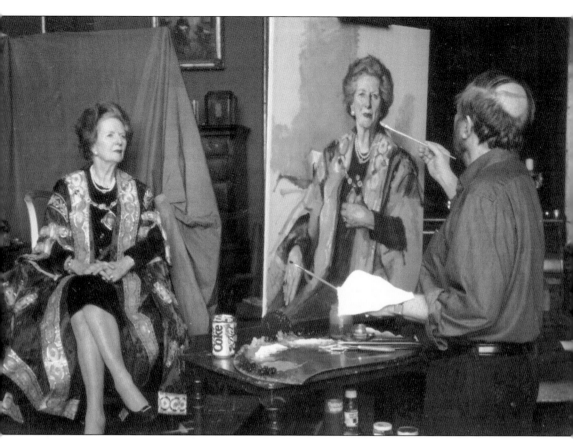

On February 5, 1994, Margaret, Lady Thatcher of Finchley, former prime minister of Great Britain, succeeded Warren Burger as chancellor of the College. She performed as chancellor with the same determination of will that had marked her political career. She was actively involved in private fund-raising and was the first prime minister since Winston Churchill to address the Virginia General Assembly in Richmond, seeking legislative support both for the College and for higher education in all of Virginia. Chosen as an honorary member of the class of 2001, the chancellor was popular with students because of her insistence on spending time with them in various ways when she visited the campus. Her portrait for the College was commissioned to artist Nelson Shanks, portraitist of many of the luminaries of the late 20th century, ranging from Pope John Paul II to opera singer Luciano Pavarotti. (College of William and Mary.)

Ever the scientist, Thomas Jefferson poses in front of the construction of Tercentenary Hall, a $9.35-million state-of-the-art classroom building for the geology, applied science, and computer science departments, dedicated on October 27, 1995. The difficult name soon yielded to the nickname "T Hall", although the building was later renamed McGlothlin-Street Hall. (College of William and Mary.)

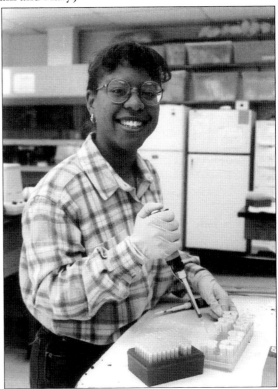

Student Candice Brown works in the biology laboratory in 1996. Upon graduation in 1998, she received a National Science Foundation graduate fellowship at Duke University in North Carolina. As in other academic programs at the College, undergraduate research in collaboration with a specific faculty member is strongly encouraged. In 2006, biology faculty published more articles about life sciences than any other primarily undergraduate university in the nation. Students were active co-researchers and authors. (College of William and Mary.)

Near the end of the century, athletics brought consistent distinction to the College. An average of 500 students each year would compete in 23 teams under the name the Tribe. Shown are the Women's Colonial Relays of 1994, above, and the Colonial Athletic Association football champions of 1996. The College had always strived for an appropriate balance between academics and athletics, and at the beginning of the 21st century, 95 percent of student athletes were graduated, 2 graduating athletes had been named Rhodes Scholars, and 42 had been elected to Phi Beta Kappa. The College had seemed to fulfill the notion of Thomas Jefferson in 1762 that "Exercise and recreation . . . are as necessary as reading; I will say rather more necessary, because health is worth more than learning. A strong body makes the mind strong." (College of William and Mary.)

In January 1997, members of the William and Mary Choir were given this view of the inauguration of Pres. Bill Clinton and Vice Pres. Al Gore, center. The inauguration ceremony was planned by Susan A. Magill, executive director of the Joint Congressional Committee on Inaugural Activities, and chief of staff to Virginia senator John Warner, at the podium. Ms. Magill later became rector of the College. "It was one of the most incredible experiences of my life," sophomore Jeremy Smith told the *Flat Hat*, saying he had come within five feet of the new president and was able to hear his thanks for the performance. "I was very proud of the way the choir performed with intelligence and great heart," said choir director James Armstrong. "They represented the College of William and Mary, the community of Williamsburg and the state of Virginia with great style and dignity." (College of William and Mary.)

Students associated with the Reves Center for International Studies traveled to the University of Ghana, in Accra, in the summer of 1999. Classes on West African and Ghanaian culture were complemented by visits to the fishing villages of the southeast coast and the prisons from which slaves had been exported to Europe and America. "The program," said Poul Olson, above, "succeeded in shaking us from the security of our own Eurocentric world by forcing us to step outside of ourselves. Unlike Americans, Ghanaians, we learned, don't dwell on what they lack in life. Instead, they make do with what they have and focus their energies on sustaining and nurturing relationships and community." Student Keisha Hill makes notes on her visit beside the Gulf of Guinea, below. That same summer also took William and Mary students to post–civil war Bosnia. (College of William and Mary.)

Former U.S. secretary of state Henry Kissinger was sworn in as chancellor of the College on February 10, 2001. His election to the post by the Board of Visitors was, in the words of Pres. Timothy J. Sullivan, an extension of what had been started under his predecessor: "The internationalization of the College is the most pressing and most promising opportunity that we have before us. Chancellor Kissinger is uniquely qualified to assist us in an effort so ably launched by Chancellor Thatcher." The election was immediately controversial, in large part because of Kissinger's role as Richard Nixon's secretary of state during the Vietnam War. Demonstrations and teach-ins were held across campus on the weekend of his installation. As chancellor, Kissinger was a proactive presence among students when on campus. The encounters were generally reported to be revealing and interesting. "Ask me any question," he said at the opening of one of them, "and I'll give you as honest an answer as I can." (College of William and Mary.)

Thomas Jefferson IV, class of 1998, William and Mary School of Law, visits with his ancestor and fellow alumnus Thomas Jefferson. Looking back from the perspective of his legal career in corporate and private equity mergers and acquisitions, he reflects now on a college that was not much changed over its history in one respect. "The school now offers its students some of the same benefits that made it successful in the late 1700s. Primarily, these include the ability to work directly and extensively with one's teachers in delving into areas of interest inside and outside of classes. The relatively small size, together with the willingness of professors to give their time freely makes this possible." Like his distant cousin, he points to specific professors who helped set the course of his life. "That W&M does what it does as a state school with the budgetary restraints that that entails is nothing short of remarkable." His heritage was little noted while a student "until graduation time, which became my 15 minutes of (undeserved) fame." (College of William and Mary.)

NASA astronaut David Brown, class of 1978, addressed the opening convocation of 2002. "It only took [James] Blair five years to establish the university," he said, " which is a pretty remarkable accomplishment I think I have a better chance of making it in a shuttle than [Blair] did in establishing this College in 1691." In an email from space to his former gymnastics coach, Cliff Gauthier, and others, he talked about the pitfalls of weightlessness and the view of the Earth floating past his windows. "My crewmates are like my family," he said, "it will be hard to leave them after being so close for 2 1/2 years." On February 1, 2003, the crew was lost in the explosion of the shuttle *Columbia* as it returned to Earth. In a memorial service February 12, 2003, Coach Gauthier described a friend with whom he would as likely go fishing as coach gymnastics. "He would tell you," he said, "Never hesitate to take a risk to follow your dreams, and when following those dreams, pursue them with complete honor, dignity, and integrity." (College of William and Mary.)

Away from the warm climate of Virginia, graduate students of the Virginia Institute of Marine Science find themselves at or near the bottom of the world. Lila Gerald sits near the top of New Zealand's Franz Josef Glacier in 2004, above. "We ascended the rough surface of the glacier, stopping to axe out grooves and ledges so that we'd get a better grip. There were a few rope bridges that we had to cross which spanned over deep crevasses." Dr. Hugh Ducklow, kneeling at left, below, was head of the Palmer Station Long-term Ecological Research Program in Antarctica in 2004. Kneeling at right is Michele Cochran, and standing from left to right are Bob Daniels, Beth Waterson, Kristin France, and Will Ducklow. "It has been very rewarding to bring both undergrads and grad students down here," said Dr. Ducklow, "introducing them to all the beauty, mystery and challenges we've experienced." (College of William and Mary, Virginia Institute of Marine Science.)

On April 7, 2006, the College planted its feet firmly in the new millennium with the investiture of a new chancellor and the inauguration of a new president. Retired Supreme Court justice Sandra Day O'Connor took on the chancellor's robes. "What a special honor it is for me," she said, "to join the likes of George Washington, our first president; John Tyler, our 10th president; and more recently our former beloved Chief Justice Warren Burger, and Lady Margaret Thatcher, whom I so enjoyed and admired, and former Secretary of State Kissinger I will treasure the privilege of my association with this great college and its role in our nation's development and history and to participate in finding ways today to provide leaders in our nation's fourth century of existence." She invited students to take part in 2007 in a planned World Forum on the Future of Democracy that would be the culminating event of the 400th anniversary celebration of Jamestown, "a little town down the road here, where American democracy and the rule of law and free enterprise and cultural diversity first took root." (College of William and Mary.)

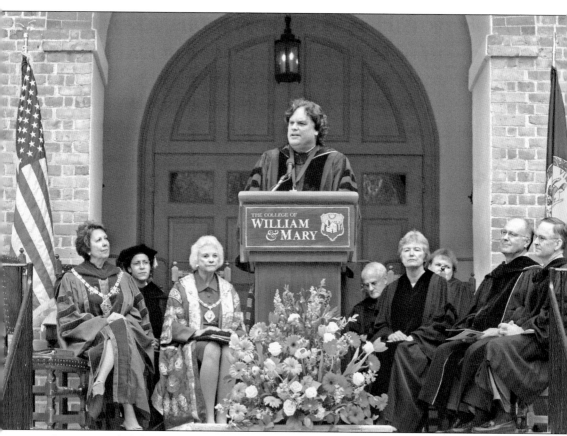

Gene R. Nichol became the 26th president of the College of William and Mary on the same day. "It was no modest undertaking, in 1693," he said, "to seek a new world, with paper charter—without ease, without resource, without comfort, without security. But James Blair and his cohorts nonetheless came remarkably well armed—with hope, with courage, with a stubborn determination to press enduring values and to paint visions anew." A lawyer, writer, and teacher of constitutional law and civil rights, he promised "To more vigorously open our doors and open our lives to all who have the wit and the will to master our challenges—regardless of wealth or class or pedigree or station." And he looked out far beyond Williamsburg to bring "the wonders of the globe to the College and the talents and capabilities of the College to the broader global community in return. . . . We seek the world not just from self-interest or calculation, but to understand our fellows, to understand ourselves, to understand our futures—and to make a mark for the largeness of mind worthy of a great university." (College of William and Mary.)

The College of William and Mary has played a proactive role in world history since its first days in the 17th century. The product of an expanding universe of ideas, aspirations, and knowledge, it has inevitably found its own path, helping a new nation to do the same. And like many who find new paths, it has been able to return to a position of respect for its origins, helped by the always-refreshing energy of youth. (College of William and Mary.)